NORTH BRISTOL
Sea Mills, Stoke Bishop, Sneyd Park & Henleaze
THROUGH TIME
Anthony Beeson

AMBERLEY PUBLISHING

To the shade of
Hugh Gwynne Williams
1933–1999
An English Gentleman

There is a land of the living and a land of the dead and the bridge is love, the
only survival, the only meaning.

First published 2014

Amberley Publishing
The Hill, Stroud, Gloucestershire, GL5 4EP
www.amberley-books.com

Copyright © Anthony Beeson, 2014

The right of Anthony Beeson to be identified as the
Author of this work has been asserted in accordance with
the Copyrights, Designs and Patents Act 1988.

ISBN 978 1 4456 1542 4 (print)
ISBN 978 1 4456 1565 3 (ebook)

British Library Cataloguing in Publication Data.
A catalogue record for this book is available from the
British Library.

Typesetting by Amberley Publishing.
Printed in Great Britain.

Introduction

'Stoke Bishop has less community of interest with Bristol than London has with Brighton,' stated Francis Tagart from the luxury of his Old Sneed Park mansion on 16 January 1885. These sentiments echoed those of a neighbouring Sneyd Park landowner who enquired that same month, 'What has Bristol done for Sneyd Park?' The remarks were engendered by the threat of the Boundary Commission proposals to include the two Gloucestershire communities within the city limits and encumber them with rates. This was finally accomplished in 1904.

For decades it rankled with Bristolians that the wealthiest citizens made their fortunes within Bristol, enjoyed its benefits and yet contributed nothing to its rates as they resided beyond the city boundaries. The plea of the escapees was that beyond the Downs, all was country and not suitable for inclusion within a city's boundaries. In truth it almost was still until the 1930s, although the rurality of Sneyd Park itself was more of the Marie Antoinette variety. In the 1880s, less than two dozen habitations stood between Stoke Bishop, Shirehampton and Westbury village. In 1851, the entire area only boasted 500 inhabitants. If the villas of Sneyd and Stoke bore little comparison with central Bristol then they also bore little resemblance to the few cottages and farmhouses of Sea Mills or those of Stoke Bishop village itself. The wish for rurality contrasts strikingly with the situation in 1800 when Bristol's merchants in general were mocked for wanting to live in the city centre to be as close to trade as possible.

North-west Bristol has some of the earliest archaeological remains to be found in the city, from the Neolithic cromlech of Stoke Bishop to the little understood Roman port of Abonae at Sea Mills. Founded in around AD 50, many tiles bear the stamp of the Second Augustan Legion, suggesting an official link with the fortress at Caerleon. The construction of the Portway and Roman Way in the 1920s saw virtually no archaeological recording beyond the foundations preserved in Roman Way, which may have joined to a large apsidal room or building beneath the road. A polygonal corridor by the harbour hints at a temple, and finds include a bronze toe from a life-sized statue and an altar with images connected to Jupiter Heliopolitanus. Abonae consisted of dwellings, shops, and workshops, with accommodation above. Grander houses or official structures are hinted at by the building found on the Roman Way and the fine tesserae found in Hadrian's Close. One theory puts the main settlement on the Somerset bank of the Avon, heading a road from Gatcombe.

The medieval mills that gave the village the name 'Semmille' straddled the Trym at the tidal reach, near Avon Way. A 1712 map of Westbury parish in the National Archives shows nothing at Sea Mills beyond these mills and their houses. That year, Joshua Franklyn and investors leased 100 acres of land and commenced the construction of Britain's third wet dock. For fifty years, this dock brought prosperity to its straggling hamlet.

The post-1919 garden suburb estate of Sea Mills Park was developed to meet the demand for housing. It was remarkable for the homogeneity of its housing types and its sensitivity in adapting the original plan to meet the contours of the site. It was a self-sufficient country village, built on land sold and given by the admirable Philip Napier Miles of King's Weston, who took a great personal interest in its facilities and layout. Its planners took pains to leave many of the original trees on the estate in situ. It is now a conservation area and one of Britain's finest examples of a garden suburb.

Much of the area covered by this book belonged to the See of Worcester. Snead (later Sneed and Sneyd) derives its name from an enclosed deer park. Following the Dissolution, the new owner built the hilltop mansion. Over the centuries, parts of the estate were sold, enabling new properties like Stoke House to rise. By 1847 new houses were for sale in Rockleaze. An 1853 Act of Parliament permitted development of land in Sneyd Park, and William Baker is credited as a major developer. Modern expansion occurred following the demise of the Druid Stoke and Old Sneed Park estates. The splendid country residences designed by the Stride Brothers between the 1920s and 1970s add much to the area. Alas, the mania for 'truly rural' largely extinguished the very thing that the new residents so desired, although fortunately much is now protected. Having lost two sports fields off the Shirehampton Road to infilling in recent decades, it is even more important that open areas as such Stoke Lodge are protected.

From the 1860s, the commercial aspects and rurality of the Downs gradually disappeared. Estates and farms in the area from Druid Stoke to Westbury were entitled to graze considerable numbers of sheep on the Downs, but it became increasingly difficult to find sufficient grazing for more than a few months. Even the smallest encroachment, such as a new house drive, was opposed. A road laid across the Downs from Rockleaze for the convenience of Sneyd Park residents annoyed everyone else and was soon removed.

From 1900 onwards, as Bristol expanded, Westbury Park and Henleaze were natural housing developments, at the expense of former private estates. The name Henleaze appears to be a verbal corruption from the seventeenth-century Robert Henley's House ('Henley's' to 'Henleaze'). The 1930s saw the greatest expansion and compulsory purchase orders later completed the infilling.

This volume contains four textual peregrinations through areas formerly within Westbury and Henbury parishes. These include Sea Mills, Stoke Bishop, Sneyd Park, Westbury Park and Henleaze. Walks commence from Shirehampton Park, the Downs, Wood End and Coldharbour Road. The illustrations have been chosen for their rarity and come from the author's own collection, those of the Bristol Reference Library and from private albums.

My thanks to Antony Berridge, Bill Blackmore, Jane Bradley, Andrew Brozyna, Julia Carver, Jackie Claridge, Keith Dubber, Dawn Dyer, Andrew Eason, Manuel Gosano, Barrie Havens, Sally Knowlson, Jane MacFarlane, Rosemary Scott, Andrew Townsend and Eric White.

Walk One

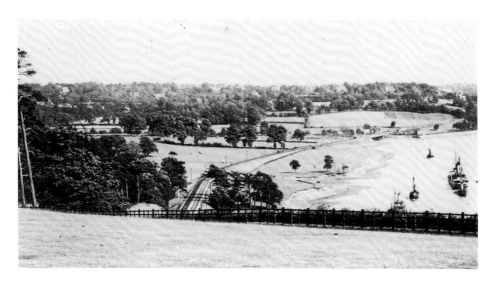

The View from the Park, 1908

'There is but one view from the park that deserves notice and this includes the river Avon and Sea Mills, they appear at a short distance, and are backed by the Folly-wood,' wrote Julius Caesar Ibbetson in 1793 of the landscape in the photograph above. To the left and cut by the tracks of the Bristol Port Railway are the trees of Crabtree Slip Wood. Beyond this, the first hedge ends to the left at one of Sea Mills Farm's buildings. The isolated, long west-facing byre stands where numbers 114–116 Portway would rise, with Sea Mills Primary School beyond. The farmyard itself lay north-east of it. By 1926, the Portway had cut through this landscape and much of the new estate was built on these lovely fields. In the photograph below, Sea Mills harbour and its signal station appear to the right. The empty fields beyond the harbour lead the eye to Sneyd Park, its mansions and the Folly Woods.

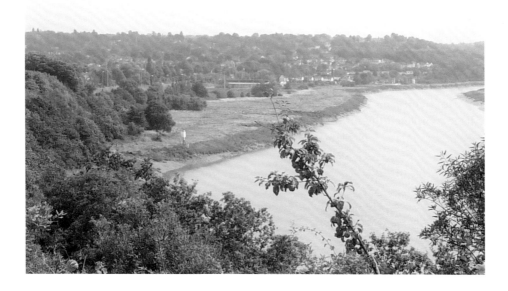

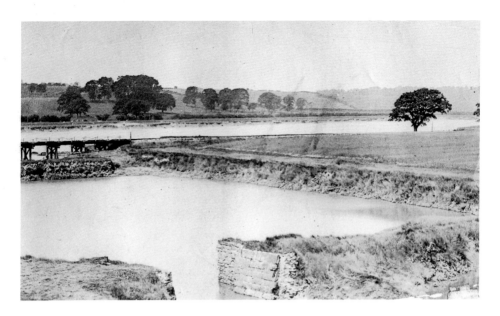

Sea Mills Harbour 1870 and 1928; Restricted by Modernity

The earliest photograph of Sea Mills harbour above shows the recently constructed single-track railway bridge that henceforth permanently barred anchorage to large vessels. In 1906, the present twin-track iron bridge replaced it. By 1870, the 1712 wet dock had long been ruinous, although Ibbetson in 1793 mentioned a projected restoration. Even then, some believed these harbour walls to be Roman, although they actually date from 1712. Defoe records the new harbour as capable of sheltering 150 vessels. In 1839, a plan to expand it to accommodate Brunel's Great Western and other new ocean steamers, unable to navigate to Bristol, was a real possibility. Vested interest and Bristol Corporation's incompetence scuppered it, allowing Liverpool to become the ocean mail steamship port to New York. Sheep graze the Avon's Somersetshire banks where once a huge beech grew capable of sheltering 'a troop of horse'. Victorian cottages and an Edwardian corner shop line the harbour below.

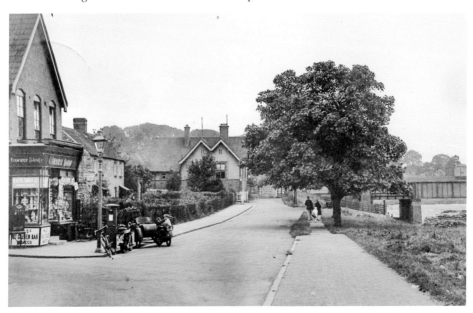

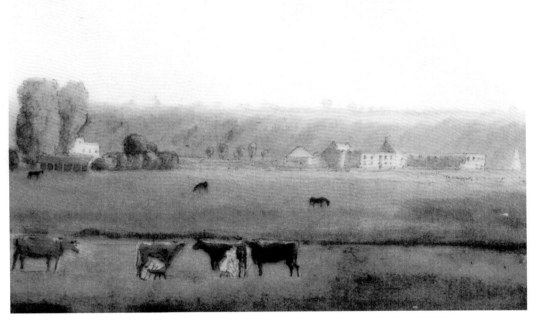

'The Store Houses ... are Now Fallen into Decay', 1793

'Scarce a roof remains perfect; and those buildings that are occupied, the inhabitants are as wretched as the hovels', wrote Ibbetson of Sea Mills. By the time Samuel Jackson painted them in 1830 the greatest warehouse running north–south at Dock Mead (now covered by the railway station) had partially collapsed. A smaller east–west warehouse remained but was unroofed. Beside them stood the 'new' public house and gardens, which survives as number 1 Harbour Wall. This had been built for convenience adjacent to the docks around 1720 to supersede the Sea Mills tavern, the Hermitage (seen below left) by the Sea Mills. A byre in Sea Mills Lane fronts two fine Georgian houses, number 79 and its lost neighbour number 81. Jackson's complete painting is taken from the site of the Sea Mills, now at the bottom of Avon Way, where the Trym was guided into three parallel channels. The southernmost fed a reservoir at the docks.

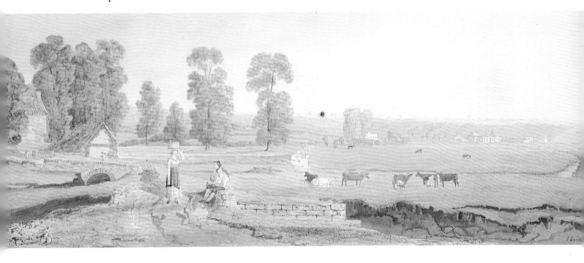

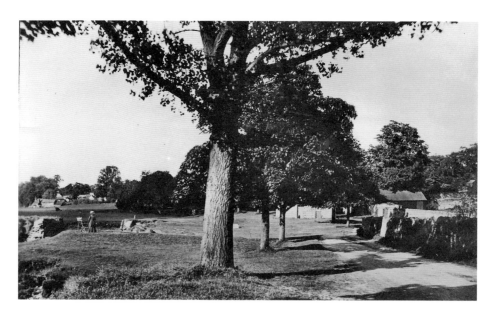

'At Sea Mills. A Pleasing Subject for the Pencil.'

The Trym valley looking towards the ancient buildings that once clustered north of the junction of the present Avon Way and Sea Mills Lane. Distantly, the gable of the Hermitage appears, then a farmhouse dated 1712, and until the early 1920s it boasted popular tea gardens. Behind it are farm buildings and cottages. Before these are the long row of ancient mill cottages, once part of the original Sea Mills that straddled the river at the tidal reach. All were demolished in 1938 to straighten the winding Sea Mills Lane. Less rustic was the sewage works that existed in the Bristol Corporation yard with the Sea Mills wood to their right. A byre beyond the gardens of the Georgian houses in Sea Mills Lane appears on the right. The river was later straightened and the banks raised during the laying of a sewer. The stonework immediately left of the artist originally formed part of a harbour reservoir, later obliterated by the Portway viaduct.

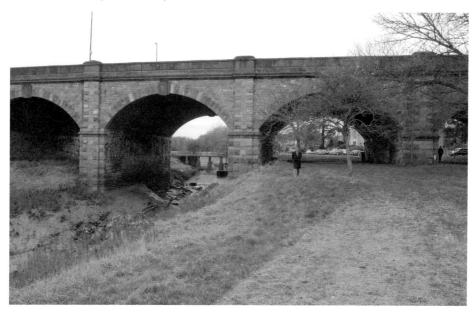

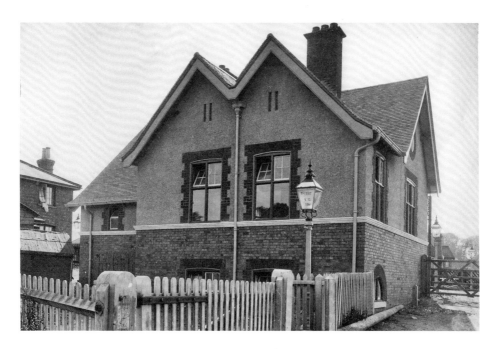

'To the Trains', Sea Mills Station, August 1906

A pointing finger and directional text engraved on the lantern glass above directs passengers to the new Arts and Crafts style station building on this official Midland Railway photograph. The 1903–07 doubling of the track to Avonmouth occasioned the construction of the station and the adjacent bridge over the Trym. Previously, a small wooden building sufficed for passengers on the 1863–65 Bristol Port & Pier Railway line between Hotwells and Avonmouth. The stationmaster's house to the left was built in 1894 on the site of a 1712 warehouse. The 1906 photograph below shows the attractive platform façade of the booking hall. The door on the right led to the ladies' waiting room. Within living memory, when the station was still staffed, the beauty of its platform garden was locally famous. An idyllic rural landscape may be glimpsed beyond, still untroubled by either Portway or estate. The station building is now a commercial office.

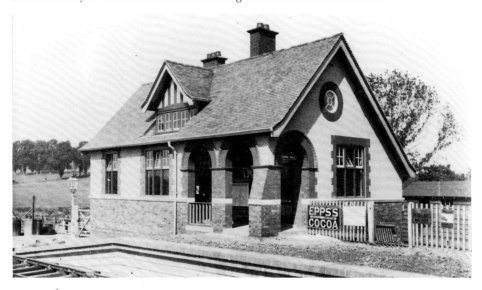

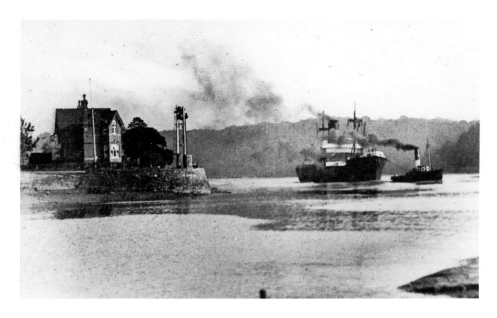

A New Signal Station for Sea Mills, 1897

In June 1896, the Clifton engineer and architect John Martin McCurrich of Bristol's dock engineer's office submitted plans for a signal station at the entrance to Sea Mills harbour. The three-bedroom house was built on a 6-foot concrete raft and was ready by 1897. Cattybrook bricks were used with Bath stone facings, while the roof employed Bridgwater tiles. The angled projection held a kitchen-cum-living-room. Downstairs were a larder, stores, scullery and a modern 'telephone room'. The balcony and eastern extension were later additions. The lavatory was flushed by a rainwater cistern and joined the main sewer, whose outfall was through the quayside just west of the house. This sewer ran from the chemical treatment plant at the junction of Sea Mills Lane and the present Avon Way. McCurrich's annual salary was £1,000 when the admired Scottish engineer died in 1899, aged forty-six. A new Moderne-style signal station replaced the building around 1953.

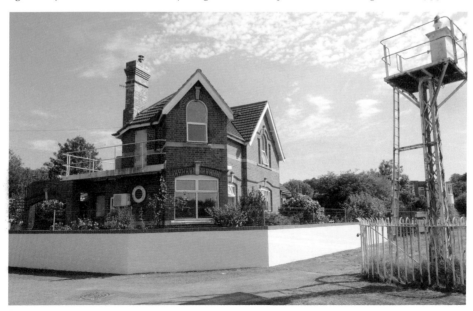

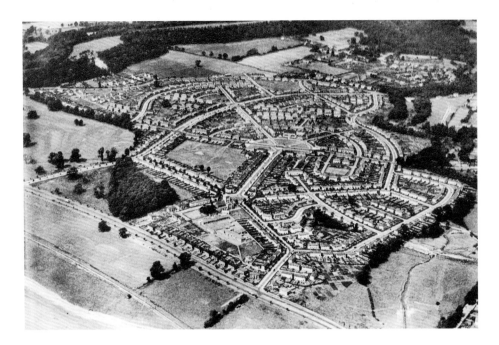

A Badge of Honour

Sea Mills Park and Sea Mills Square, 1935. The final layout differed in density and use of some areas from that originally announced. Houses were only awarded to respectable families in employment, and there was great competition among prospective tenants to be chosen. It was considered a badge of honour to live there. Only in recent egalitarian decades did the council try housing problem families at Sea Mills in the hope that respectability would rub off. Instead it caused problems for their neighbours. Tenants originally abided by strict regulations, and uniformity on the estate was strictly enforced even down to having the height of their privet hedges measured by an official with a stick. Both hedge and verge cutting, however, were council responsibilities. Social life revolved around the churches, shops, the recreation ground and the Conservative Club in Westbury Lane. No public houses were permitted until the Progress Inn opened in Coombe Dingle.

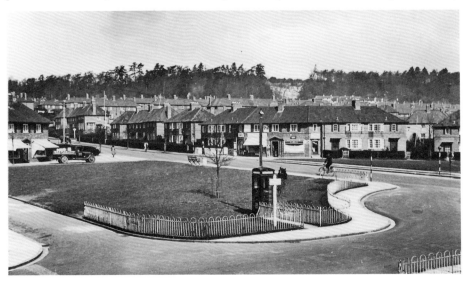

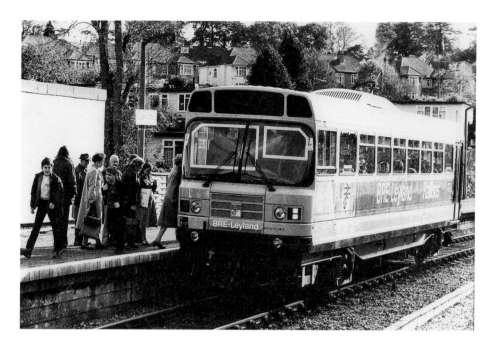

Railbus on Trial, 17 November 1981

At Sea Mills, passengers experience the new lightweight Railbus then starting a six-month trial on the Avon Link Line from Bristol to Severn Beach. The novel vehicle was developed by British Rail Engineering and Leyland Vehicles and had a bus body with a train undercarriage. Seen as a way of saving branch lines from closure, it could carry ninety passengers, with fifty seated and forty standing. The diesel fuel consumption was 10 miles to the gallon and it was capable of achieving speeds of up to 75 mph. Beyond the Railbus the prefabs of Hadrian Close terrace up the hillside towards J. R. Merritt and H. E. Todd's 1930s developments of Horse Shoe Drive and Sabrina Way. Finds, including fine tesserae, suggest that Roman Abonae's most important buildings await discovery in the same area. The ground now covered by allotments was a riverside quay in antiquity. The 1920s photograph below showing a steamer leaving the quayside reverses the view.

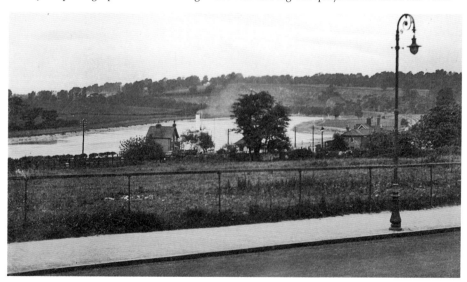

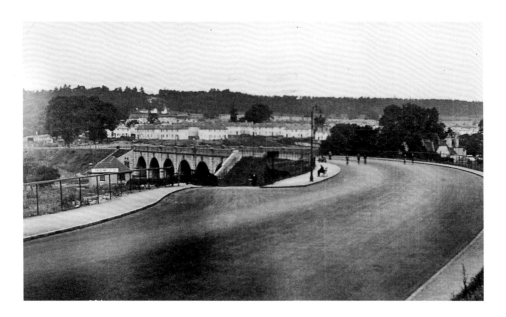

'A Grand Approach to Sea Mills Park', 1926

Sea Mills Park seen from the spectacular £800,000 Portway where it crosses the harbour bridge. St Edyth's tower is yet to rise above the Pentagon but the photograph above illustrates how the estate planners retained many of the original trees in the landscape. At the far left, Sea Mills Farm's outbuildings still overlook the new road and the harbourside shop appears below. The viewpoint was the heart of Abonae, and Hadrian's Close then remained undeveloped. On King's Weston Down new private houses in Westbury Lane show white against the hillside below the quarry. To the bridge's right, the gables of a now lost Georgian house appear. Farmer Goddard of Sea Mills Lane and his daughter, Nell Davies, had popular riding stables behind here in the 1940s. The horses browsed the riverbanks and hay was stored beneath the bridge arches. The lower photograph, taken from where Sabrina Way would later rise, shows harvesting around 1930.

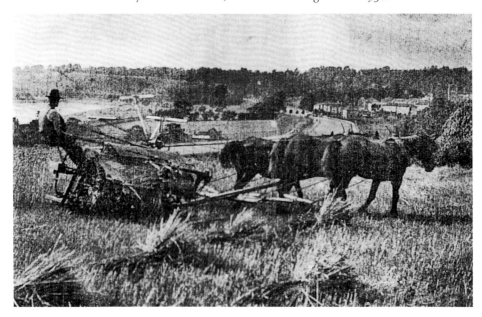

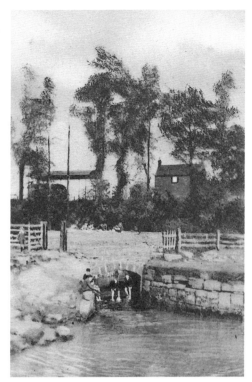

A Lost Bridge and Forgotten Mills

Only a lane between numbers 63 and 65 Trym Side remains of a continuation over the Trym of the Roman 'Mariners' Path'. A 1712 map calls it the 'Mill Road to Kings Weston'. A southern branch – 'The old Mill road to Bristoll' – transversed the fields until reaching Stoke Bishop hamlet. In 1712, Sea Mills Lane is marked as 'The new mill road to Bristoll made by Mr Loyd'. Edward Loyd owned Druid Stoke to the east. The bridge, pictured here in 1904 (left), spanned the Trym to the east of what was later Trym Cross Road bridge, approximately opposite number 33 Sea Mills Lane. Farm buildings, then in the lane, appear beyond. A millpond fronting it was connected with important mills that once spanned the Trym here at the highest reaches of the Spring Tide. These appear on eighteenth-century maps but had disappeared by the following century. The bridge was removed and the meandering Trym straightened in the 1950s.

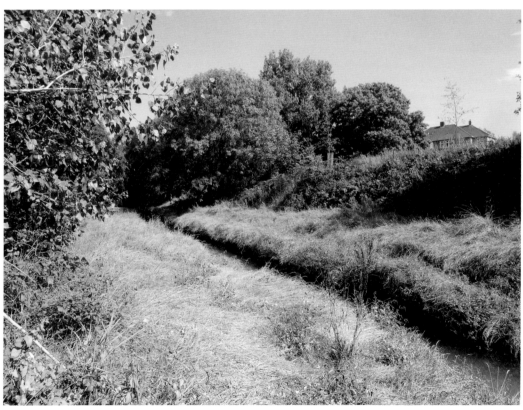

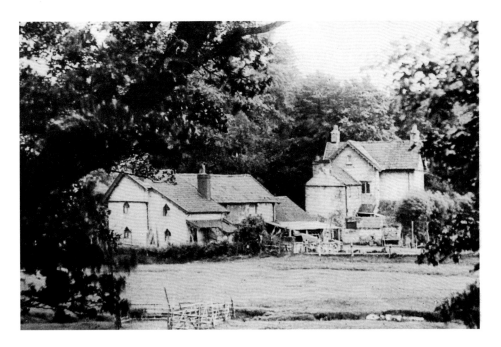

'The Mill Houses etc', 1907

At the head of 'Sea Mill Pill', and just below the highest reach of spring tides, were the Sea Mills. Shown on the 1712 map, they spanned the Trym within a rectangular building with an east-facing triangular cutwater protruding at its southern extremity, adjoining a sluice gate. This antiquity did not survive the eighteenth century but its Mill Houses, seen above, did until 1938. To their right appears the later Sea Mills Tavern (The Hermitage) of 1712, which stood at the end of Mariner's Path (now Avon Way). This curved in front of these buildings joining 'the new mill road to Bristoll' (eastern Sea Mills Lane) and the forgotten 'Mill Road to King's Weston'. Behind the buildings a stream that flowed down through the Comb Wood (now Sea Mills Wood) joined the Trym. Part of its ditch was later utilised for a harbour leat and appears below the Hermitage.

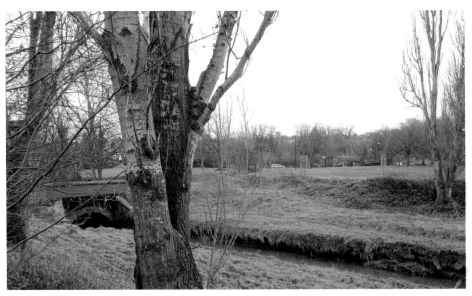

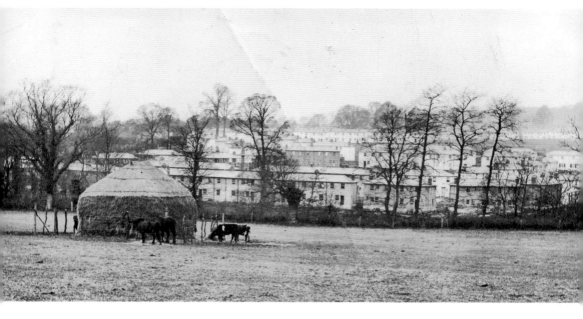

Harvest Time at Sea Mills Park, 1921

Rurality continued beyond the new Sea Mills village, seen above during construction by Cowlin & Sons. Livestock grazes where Newlyn Avenue and houses by A. E. Oaten would rise by 1927. Beyond the boundary fence and Sea Mills Lane, the Trym valley appears as a dark band. The houses of Trym Side curve around to the right to meet those in Meadway. Groveleaze's show interesting details of the construction of these 'Dorlonco' (Dorman Long Company) houses, with finished slate roofs and chimney stacks and the walls a yet transparent framework of steel girders. Brookleaze slants off to the left up the hill past some towering trees and the backs of houses in Woodleaze angle off from the Pentagon. St Edyth's Road and all between remains undeveloped. None of the houses in view are yet occupied. The first of these 250 Dorlonco houses to have tenants were numbers 21–27 Sylvan Way after August 1920.

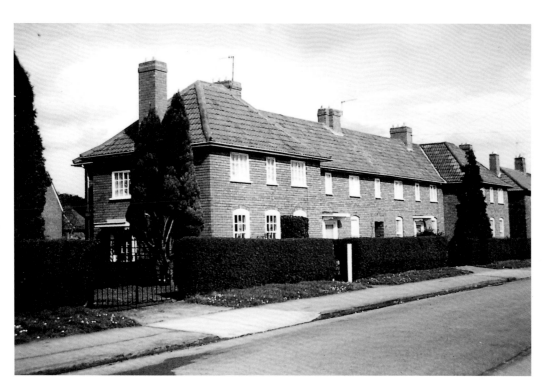

'Pleasant Cottages that that Magic Estate has Managed to Create'

Bristol's Housing Extensions & Town Planning Committee organised a competition to design houses for the proposed Garden Cities at Sea Mills Park, Fishponds and Knowle. Judged by Ernest Newton, FRIBA, and Charles Dening, FRIBA (the committee's advisory architect), the results were announced on 17 June 1919. Thirty-five architects submitted plans and ten designs were chosen. The architects of six of these designs then formed an advisory panel. The Women's Advisory Committee was also consulted. The designs complimented one another in projecting a harmonious Neo-Georgian cottage look, so appropriate for the rural locations, and were easy and economical to build. Constructed of inexpensive materials, their real visual charm was mostly down to their Georgian-style glazing, green shutters and neoclassical door surrounds, as is all too obviously seen where injudicious modern windows without glazing bars have been substituted and the unifying hedges rooted out. The photographs show an unidentified 1920s household (right) and unspoiled houses in East Parade in 1987 (left).

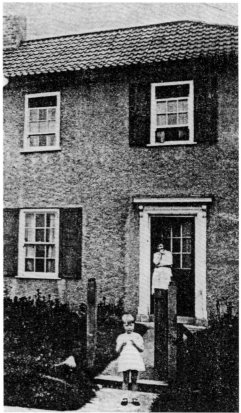

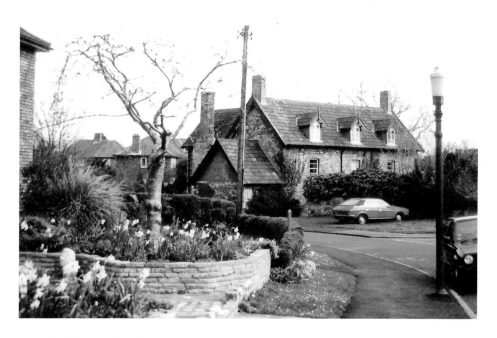

Xenophobia: Manslaughter at Sea Mills Farm

At Sea Mills Farm on 22 August 1848, the farmer, Henry Peppin, had employed Irish men and girls to assist in harvesting. Unfortunately, local men provocatively claimed a higher proportion of the field than it was possible for them to work. The Irish complained to Peppin who attempted to calm matters, but a local, Abraham Young, grew violent towards Irishman James Donovan and threatened him with his reaping hook. The following day, while stooking was progressing, Young gathered men from a neighbouring farm and, armed with sticks, they menaced Donovan, who struck and killed Young with his hook. The inquest was held in Westbury's White Lion with the jurors viewing the body in Sea Mills Farm barn. The following March, Donovan – 'a kind harmless man' – was acquitted by a jury. Sea Mills farmhouse (below, photographed in the 1980s) is dated to 1700. The above photograph is taken from where its considerable farmyard and buildings once stood.

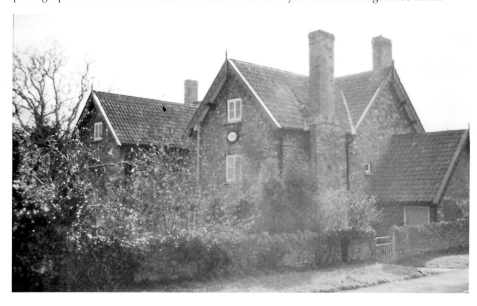

**Finishing the East Window,
12 January 1931**

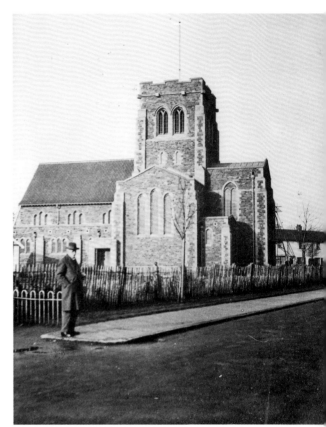

Present Sea Mills lay within Henbury parish and, lacking a church, its clergy held winter Wednesday services in Appletree Cottage, Bowden's Fields. A popular multi-parish annual event, held near the junction of the Hazel Brook and Trym, was a Rogation Service. With the birth of Sea Mills Park, services started, first in houses then outside on what is now the Recreation Ground.

In 1921, Bristol boot manufacturers Sir Thomas and Edith Lennard purchased and donated the land where the present building now stands. Sir Stanley White provided the wooden hall or 'Black Hut', used as a church from 1921 until 1928, from Filton Aerodrome. Edith died at Henbury Court in August 1921 and, in remembrance, the hall was named after St Edyth of Wilton and made a district church in 1926, when the dedication stone for George Oatley's handsome building was laid. A procession from the dedication ceremony on 15 December 1928 appears below.

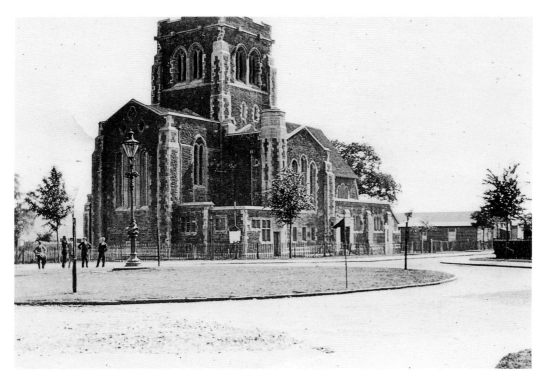

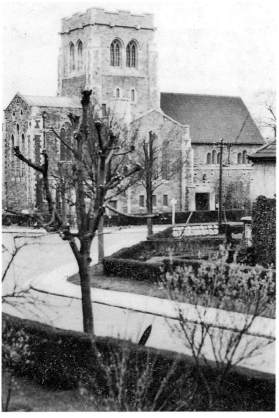

Lady Edith's Church, 1932 and 1948
An elaborate lamp standard decorates Pentagon Island below Oatley's new church, built in the style of the early thirteenth century. The earlier wooden church – known locally as the 'Black Hut' – appears behind. It temporarily housed Sea Mills Primary School before the new buildings were finished and later became the church hall. The church's tower is a landmark that can be seen from far away. Together with the side chapel it was given to the church by builders William Cowlin & Son Ltd in memory of their parents. They also donated the east window in memory of their sister Miss Annie Cowlin. Unfortunately, funds ran out before two bays of the nave and the narthex could be finished. The western wall, narthex and church hall extension were handsomely accomplished by Peter Ware in 1990. The 1947 photograph is taken from number 2 Woodleaze. For many years the church and its hall remained the centre of religious, cultural and social life on the estate.

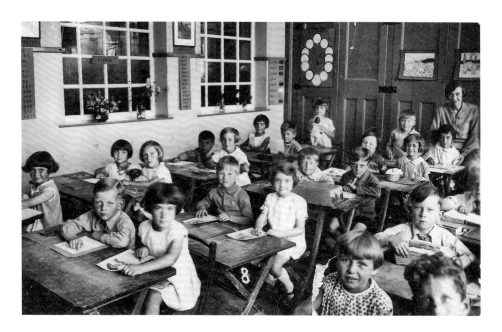

Two Generations, 1931 and 1953

Sea Mills School started life in the church hall in 1924. Alfred Oaten was the architect of the junior and infants' buildings that were subsequently built adjacent to the church in 1927/28 and 1931 respectively. These buildings in Riverleaze complement St Edyth's in their use of the same red pennant stone. In keeping with the estate they are designed in a simple Neo-Georgian style, now somewhat spoiled by modern glazing. In the 1950s, a new infants' school in a contemporary style was opened in Hallen Drive. Recent developments have seen this complex closed and pupils return to new buildings at Riverleaze. An early infants' class pauses for posterity above around 1931. Interestingly, two of the girls hold black dolls. In the 1953 photograph below, Jackie Sobey (fourth from the left in the second row) and classmates, appear with their form master, Mr Brandt (right) while J. S. Biggs, the headmaster from 1951, flanks the left.

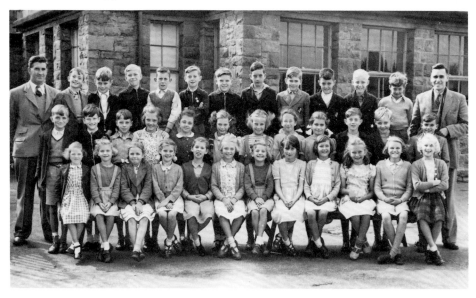

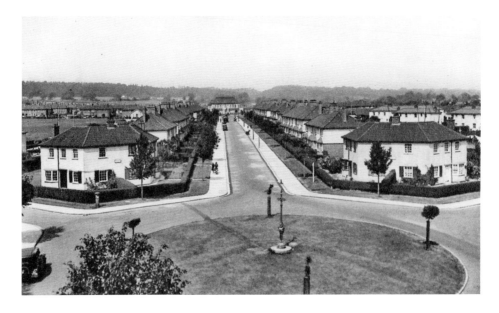

St Edyth's Road, 1931

This photograph taken from the scaffolding erected for placing St Edyth's east window looks beyond the Pentagon and down the grand prospect towards the new Methodist church on the Square. The modern viewpoint is from the tower roof. St Edyth's Road was an avenue of private houses designed to harmoniously merge with the Corporation housing of the garden suburb. The attractive houses date from 1923/24 and after the Dorlonco houses in the surrounding roads. They may possibly have been designed by W. G. Newton as they bear great similarities with his houses of 1929/30 at numbers 220–242 Shirehampton Road, which were developed for the King's Weston estate office on land originally reserved for small holdings. All were designed to blend in with the 'Sea Mills Georgian' style. Fields, soon to be developed, back the Methodist church. It may be seen how well the privet hedges of the suburb unified gardens and buildings.

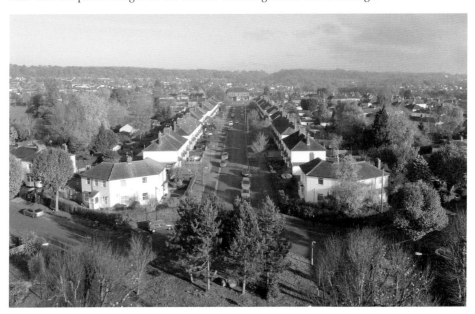

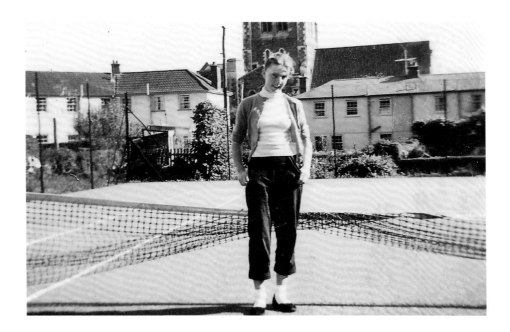

Anyone for Tennis?

St Edyth's Church Youth Club was situated off Woodleaze in the shadow of the church tower adjacent to the 126th Scout Group's hut. In 1957, Jackie Sobey poses on the club's tennis courts, backed by the church and the houses of Avonleaze. The modern photograph reverses the view and shows the youth buildings backed by Three Acre Covert and Shirehampton Park. The courts still survive, although now used for other sports. More courts were built for the villagers at Dingle Close and have recently been the focus of a residents' bid to restore them and secure their future. The youth club later changed its name, becoming the Sea Mills Boys & Girls Club. In the 1950s, there was some concern expressed locally when Avonmouth's Youth Club closed and its teenagers were permitted to join St Edyth's. Sea Mills always considered itself socially superior and (unjustifiably) feared that the new arrivals might be 'rough'.

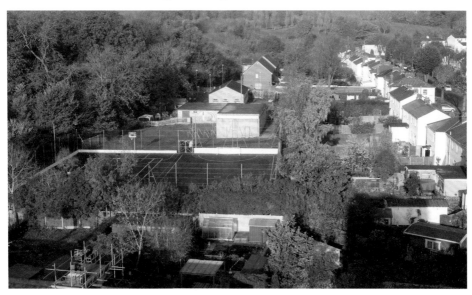

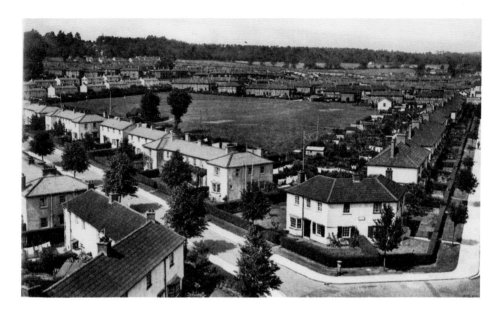

A Garden Suburb

A view across Woodleaze and the Recreation Ground in 1933 shows the completed estate had by now reached Westbury Lane. The white gables of the Haig Homes appear on the hillside in the left distance above but otherwise it is bare of houses until those of Grove Road at the distant right. The visual harmony of the garden suburb is evident. On the Recreation Ground a wooden pavilion sits at a strange angle, presumably orientated on the pitches it served. Density of development was reduced from the 1919 master plan and the Recreation Ground was doubled in size. During the war the western half became allotments, although a football pitch still occupied the eastern. Woodleaze roughly follows a footpath to Shirehampton that branched from the northern continuation of Mariner's Path at Sea Mills Farm. The house on the corner of St Edyth's Road shows the green shutters that were a feature of Sea Mills.

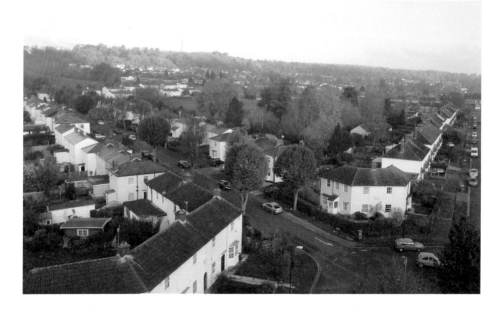

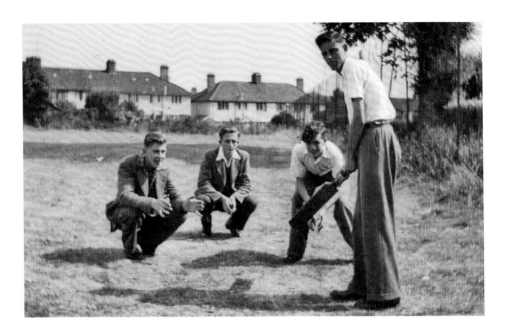

A Game on the 'Rec'

From the 1920s the Sea Mills Recreation Ground played an enormous part in the social life of the estate. It was the scene of sports, flower shows, summer fêtes and even religious services. Sports fixtures regularly took place there and, although lacking the necessary flower beds, it also in some ways served the function of a formal park for Sea Mills. Three Acre Covert and the adjacent meadow were intended as the estate's 'wild park'. The photograph above from the early 1950s shows David Sobey (second left) and members of the youth club using it for an informal game of cricket. The high, wire fencing (since removed) protected the surrounding houses from stray balls. 'The Rec' was also a gathering place for Sea Mills' young when the youth club was closed. In 2000, the Millennium promoted a grand return of the flower show there, complete with impressive marquees, sideshows, country dancing and other performances.

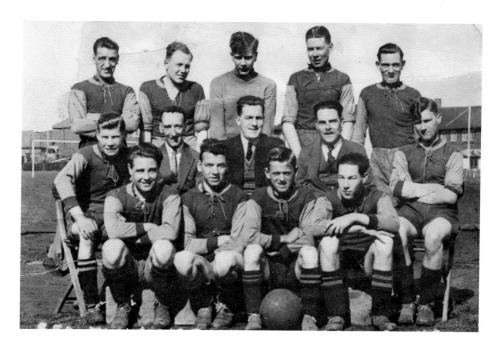

Sea Mills Wednesday

From the beginning of the estate, sport formed an important part of community life in Sea Mills Park, especially among the young. The recreation ground behind St Edyth's Road and Woodleaze hosted matches and was used for training. Here, the 1933/34 members of the Sea Mills Wednesday Amateur Football Club pose for posterity on the ground. Shirehampton's Les Jones sits second to left in the front row, proving that all were not from the new estate. Presumably the members took advantage of Wednesday half closing in the city for their sport, rather like their namesakes in Sheffield who were originally given Wednesdays for practise and matches. The Sea Mills Park Football Club was formed in 1925. In 1949, members pose with 'mascot' six-year-old Jackie Sobey while on an away match. Jackie's brother David Sobey stands behind her. The club is still in existence and has a loyal following.

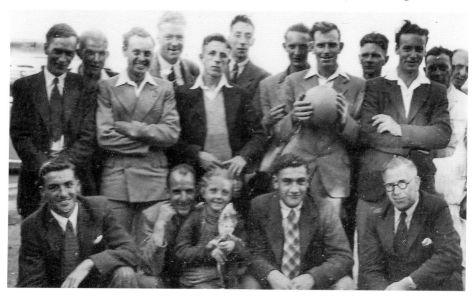

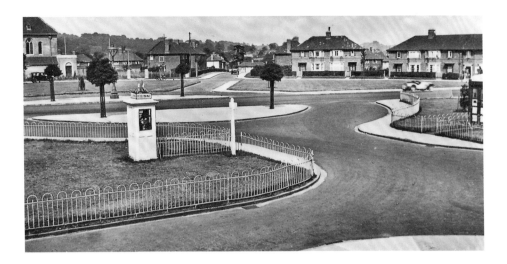

On the Square

Sea Mills Square, the village's formal centrepiece, served both as piazza and shopping centre. Its design was influenced by A. Hugh Mottram's ideal garden suburb, illustrated in a 1912 pamphlet entitled *Nothing Gained by Overcrowding*. The 1932 photograph looks across to East Parade beyond the railed approaches to telephone and police boxes. Some buses terminated here and continued to do so until the late 1970s. A commemorative oak planted by Dr Christopher Addison behind the telephone kiosk at commencement of work in 1919 still flourishes. A 1950s public lavatory was built where the sports car is shown on the far right. Closed by council cuts, it was ceremonially reopened by the Princess Royal as an attractive community café in 2012. An accompanying playground is threatened, neglecting the 'Rec' and spoiling the lawns' symmetry. The fir trees surrounding the square have now been replaced by oaks but the rose beds that were once its glory, and seen here in the 1968 photograph below, are no more.

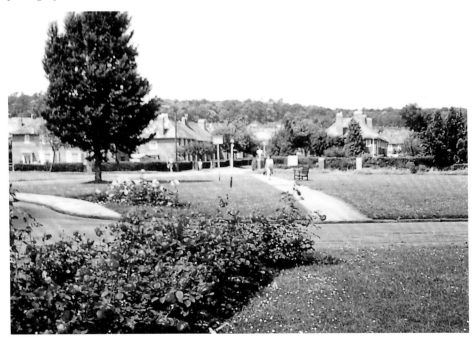

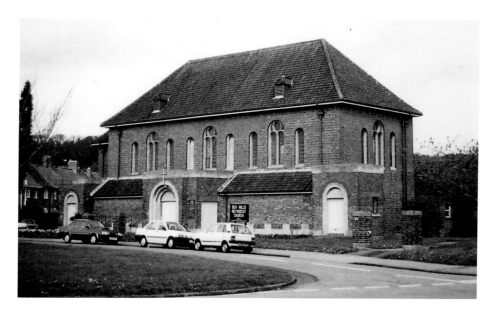

At the Basilica of Abonae

Dominating Sea Mills Square, and the main focus of that formal space, is George Oatley's Methodist church of 1930. It closes the prospect from St Edyth's, as does the latter building from the square. The Redland Circuit decided on building a church and land was bought from the council in 1928. It was opened by Mrs Letcher on 23 September 1931. Oatley's impressively simple building appears inspired by his contemporaries' idea of a small Romano-British town basilica like that at Caerwent – perhaps his allusion to Sea Mills' ancient predecessor. The 1988 photograph above shows the church after the privet hedges that once linked its gate piers, and related the building to the neighbouring properties, had been removed. Subdivided in 2005, the Methodist Housing Association had added twenty-one sheltered flats to the building by 2007, disturbing the building's symmetry. At the suggestion of Antony Berridge this development was named Abona Court in honour of Abonae.

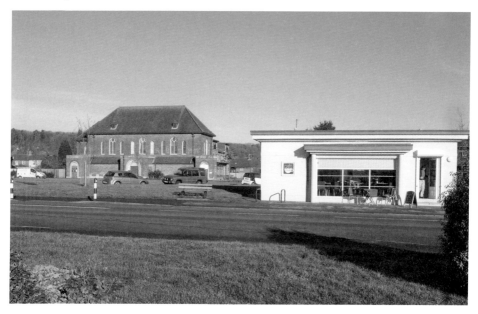

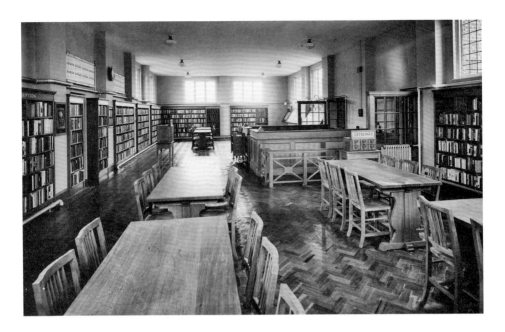

'A National University Which All May Attend'

On 12 April 1934, 'through an avenue of children', the Lord Mayor arrived by carriage to ceremonially open Sea Mills Library, before journeying on to visit the church, schools and clinic. Designed by city architect C. F. Dawson, it was the third branch opened in Bristol in 1934 alone. It consisted of one public room used for reference, lending and rear staff accommodation. It cost £3,000 and the elegant furniture and fittings were carried out in unstained Austrian oak by the Bristol firm of A. G. Matthews of Redcliffe Hill. With 6,000 books, newspapers and periodicals 'chosen to suit the student, artisan and general reader', the reference and newspaper section opened weekdays from 10 a.m. to 9 p.m. Books might be borrowed from 10 a.m. to 1 p.m. and 6 p.m. to 9 p.m. Bristol was an innovative leader in library provision in Britain and a succession of enthusiastic councils fostered the service with pride until recent, less enlightened years.

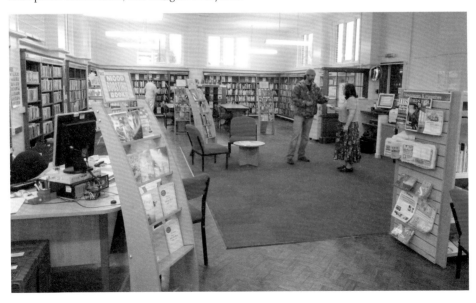

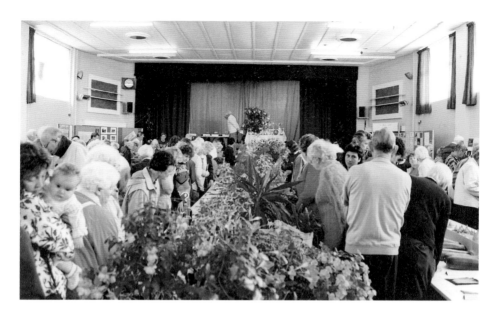

Sea Mills Park in Bloom

The Sea Mills Park Horticultural Society started an annual flower, fruit, vegetable and handicraft show on the Recreation Ground in 1927 that became second only to Bristol's in importance. The gardens and allotments available to Sea Mills 'settlers' fostered much interest in horticulture and the show ran almost every year from 1927 until 1964. Then, alas, a decline in entries and interest finally saw its demise and the winding up of the society. In 1994, Westbury Lane residents Gordon and Jane MacFarlane revived it with great success for another ten years as the Sea Mills & District Flower Show, holding it in the Community Centre and marquees in Sunny Hill. Bands, displays, handicrafts and art added to its popularity and they started a Best Kept Garden Competition. The Millennium show grandly returned to the Recreation Ground. The Community Centre was built by local residents in the late 1950s and continues to serve them.

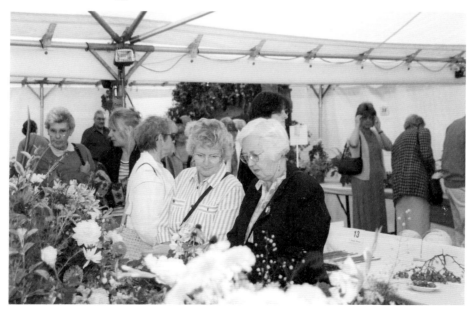

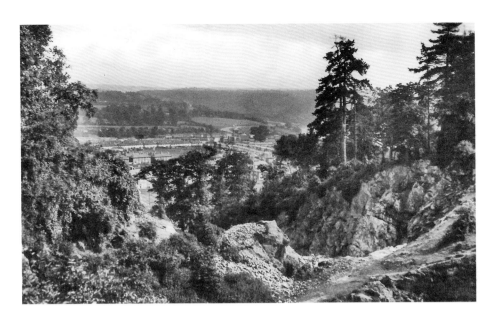

'The Country 'round Here is Very Pretty', 1934

Sea Mills Park seen from the traditional viewing spot above the quarry on King's Weston Down. 'P. W.', the card's sender in August 1934, reported feeling 'better and stronger' for their sojourn 'in the country', staying with Edward Whittle at number 4 The Pentagon. The rear façades of the houses of St Edyth's Road show up as a white stripe across the photograph pointing towards St Edyth's church. The Portway curves behind following the river. Apart from a few buildings in Sea Mills Lane, the fields beyond the trees of the Trym valley, now occupied by the Stoke Bishop estates, are entirely free of building. Freshly cut stone in the foreground suggests that the quarry had only recently closed. The card's message reminds us that even in the 1930s this area beyond the Downs was still considered to be rural rather than suburban. The 2013 photograph below looks down the old Shirehampton turnpike road across the estate.

Walk Two

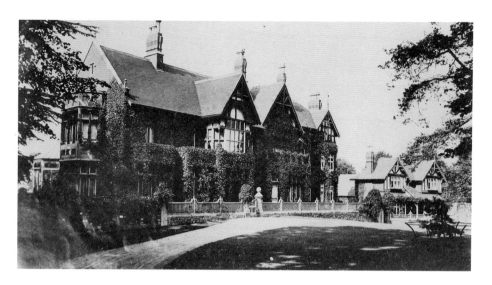

At the End of a Lost Road

Originally a private road led from Down House's circular drive across Durdham Down, joining the Westbury Road close to Blackboy Hill. It appears on maps until the 1870s and as a 'crop mark' on the 1946s aerial photographic map of Bristol. Down House was of Georgian origins, built on the site of the Ostrich Inn and, until 1904, beyond the city boundary. In 1825, Serjeant Ludlow, Town Clerk of Bristol, lived there. By 1838 it was owned by A. G. Harford Battersby and let to Richard Brickdale Ward and later to Mr and Mrs Saville. William Edwards George, son of Alfred George of brewery fame (who built neighbouring Downside in the 1840s), then bought it. He rebuilt it in a Tudoresque style together with a substantial lodge seen to its right in the 1908 photograph above. By the 1930s Lady Howell Davies lived there. Later known as Downs Hall it is now the Saville Manor Nursing home.

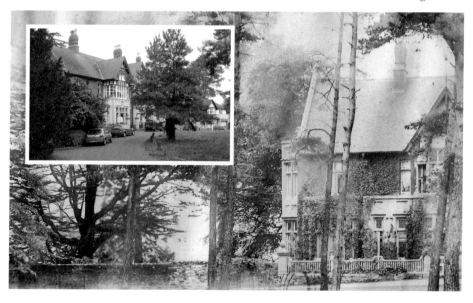

'Going from the Downs One Sees a Number of Quite Picturesque Farms'

Stoke Abbey Farm dates from around 1660 with mid-nineteenth-century alterations. It rose before the rediscovery of 'The View' and the grandeur of vistas, for its small-paned windows took little advantage of those that its elevated position afforded. A possibly coeval pyramid-roofed, two-storey gazebo overlooked Paddywell Lane and appears here in Loxton's 1918 recording. At one time owned by John Battersby Harford, the farm was purchased by the George family and later leased by Edward Green and his descendants. The Greens ran a successful dairy business based on herds of Jersey and shorthorn cows. Albert Green's milk carts were commonly encountered and deliveries of fresh dairy products were made to the city and its northern suburbs twice daily. In 1892, an embarrassing paternity case against Albert, brought by Sarah Ann Rich of nearby Cross Elms Cottage on behalf of her baby daughter Alice, was dismissed through lack of corroborative evidence.

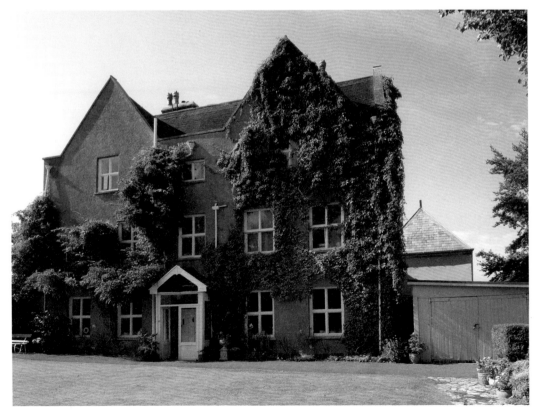

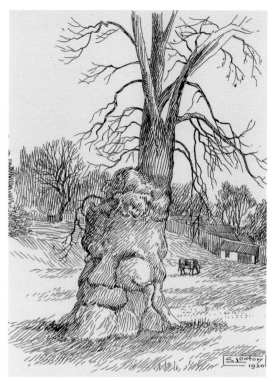

The Man-Tree ... a Lost Curiosity

Stoke Abbey Farm once possessed an ancient tree that had taken the shape of a bearded head. It bordered the lane to the right of the long barn, later converted to the delivery offices seen below in 2011. With fields under housing, the farm became a Unigate and finally Milk & More delivery depot, before closing in 2011. In 2013, the original farm buildings remain including those used by the Sneyd Park Stables. New houses are planned for the site. Paddy's Well Lane, reputedly named after Irish Drovers, and renamed Parry's Lane after the Arctic explorer, was the historic road to Coombe Dingle. Tragedy struck the Greens in 1895 when three-year-old Ethel burned to death in her nursery. Four years later, the recently formed Westbury Fire Brigade used its new engines and drained three ponds in fighting its first fire started by children in 45 tons of hay in a nearby field.

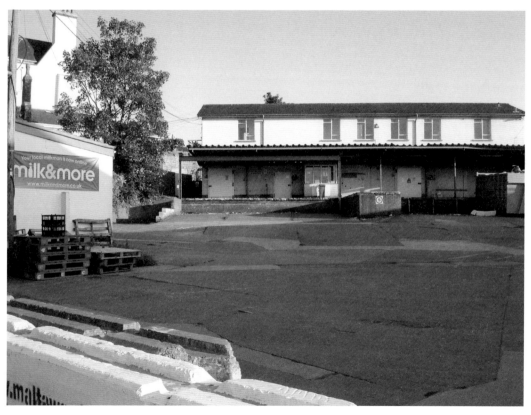

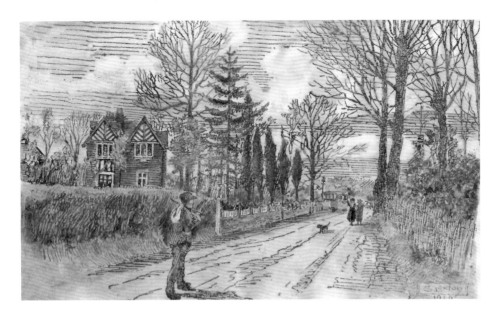

Pumping Gas, Cross Elms Cottage

Cross Elms Cottage dates from 1882 according to its commemorative plaque bearing the initials W. E. G. These recorded the landowner and its possible designer, William E. George of brewery fame, whose residence, Down House, lay at the top of Paddywell (Parry's) Lane. The cottage was the residence of James Rich and his wife and daughter. His occupation of 'Gas Manager and lamplighter' explains the property's original function as adjoining it was a little stable-like gas pumping station that governed the area's gas distribution. Its roof boasted a louvre and weathervane. Altered in 1930, the station was converted and expanded into domestic use after 1987, becoming the Old Gas House. Loxton's recording shows the cottage in 1920 shortly after Parry's Lane had been widened to accommodate modern traffic needs and commercial vehicles en route to Avonmouth. Houses arose soon afterwards. A newspaper report of 1920 states that the road was then still colloquially known as Paddywell Lane.

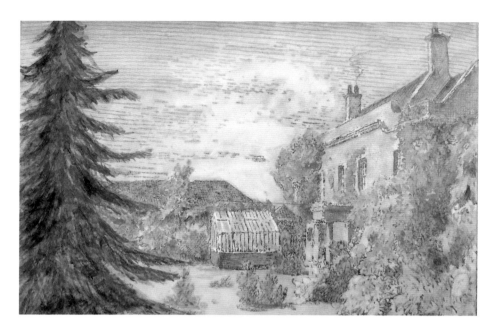

Red House Farm 'Grandly Embellished with Foliage'

Samuel Loxton's 1918 recording of Red House Farm. A date of 1654 has been suggested for the original farmhouse that between 1778 and 1811 was the home of the Quaker, Jacob Sturge. It was then given a genteel stucco façade complete with an upswept parapet, Doric porch and limestone dressings. The boundary wall with its coping of copper-slag blocks dates from this period. Sturge was both farmer and land surveyor. Later owned by absentee landlords for much of the nineteenth century, newspaper advertisements chronicle some of the farm tenants' sales of stock and equipment. In 1877, it was sold to the Wedmore family. In 1884, their tenant George Biggs retired from farming, selling his dairy cattle and Dorset Down ewes. Between 1899 and 1932, Frank Wedmore sold land to the Wills family and the main fields to the university for its athletics ground. Infilling has recently removed the southern section of its garden.

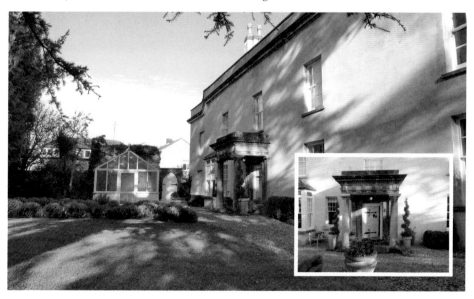

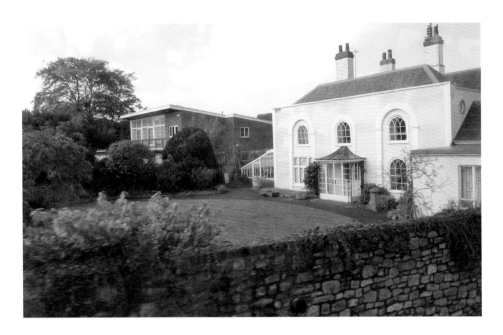

'A Capital Freehold Dwelling-House'

Around 1800, The Elms, an elegant cottage with Gothick fenestration, arose almost opposite to Red House Farm in Coombe Lane. It boasted lawns, shrubberies, and 6 acres of pasture in a completely rural landscape. Its outbuildings included a gardener's cottage, coach house and a four-stalled stable. The trellised entrance porch was originally approached by a circular drive from what is now number 31 Coombe Lane. From around 1878, its owner was Stephen Hughes, a partner in wine merchants Garrard & Bartram. A bachelor, who lived with his stepmother, he raised prize-winning cattle on his land. In 1895, he took poison in a field near Sea Mills station and the house witnessed his inquest. Soon afterwards the property was renamed 'Cross Elms'. When sold in July 1947 for £6,000, following the death of Edward P. M. Davey, Cross Elms possessed 1½ acres and had been converted into two self-contained flats.

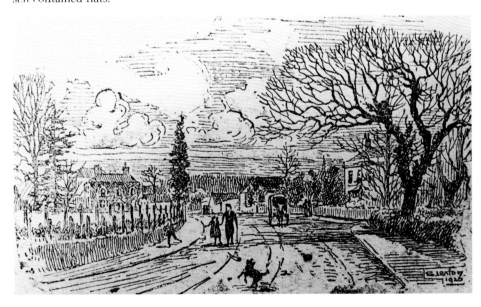

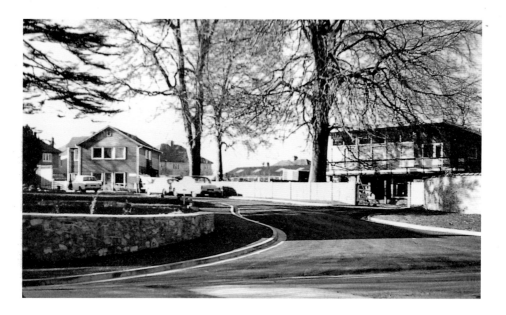

A Garden Centre and a New Road

The new owner of Cross Elms, in 1947, was nurseryman and landscape gardener K. H. Smith, of Kellaway Avenue. He established Cross Elms Garden Centre with a shop fronting Coombe Lane. The grounds featured a miniature railway complete with an ornamental tunnel that survives in the rear garden of number 2 Coombe Gardens. The 1969 photograph above shows the first houses of Coombe Gardens, which was developed across the southern and western side of Cross Elms. The main nursery greenhouse appears between the trees. Between 1978 and 1982, the second phase of developing Coombe Gardens with the Swedish-designed houses of Aneby Hus (UK) Ltd, removed the greenhouse and severely reduced the Garden Centre, which closed in the 1980s. Fairfield, the large house seen to the right below, was built immediately to the west of Cross Elms house, whose garden wall appears far right. As originally planned, more Scandinavian houses (numbers 47a and b) replaced its shop on Coombe Lane.

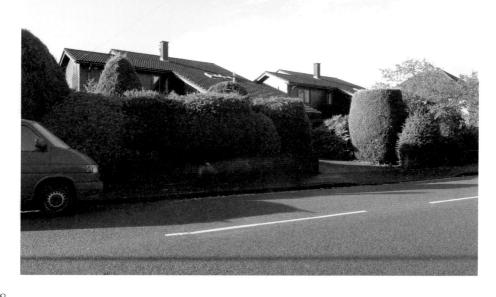

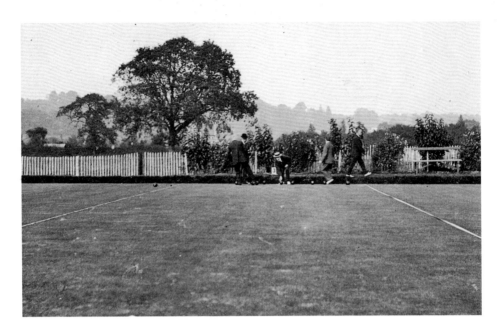

Jack of the Green

To the north-east of the University Sports Pavilion and next to the early boundary of the athletics field, there was originally a bowling green. The area was later, as now, occupied by additional outdoor tennis courts to supplement those situated near Rayleigh Road. These two photographs were taken on 21 September 1912 and show a private bowling party with young Eric Sargent and older companions identified as Messrs Bould, Boulton, Boreland and Munroe. The upper photograph looks north-east towards Canford Lane and Westbury, and shows Coombe and Henbury Hills in the distance. To the left appears the roof of Coombe Nursery house that once stood near the corner of the present Sandy Leaze. The latter road partly enshrines the traditional name of the field, Sandy Land, that it now occupies.

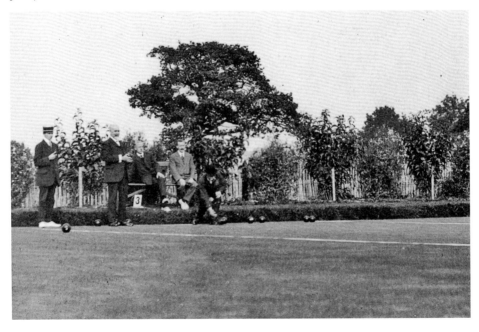

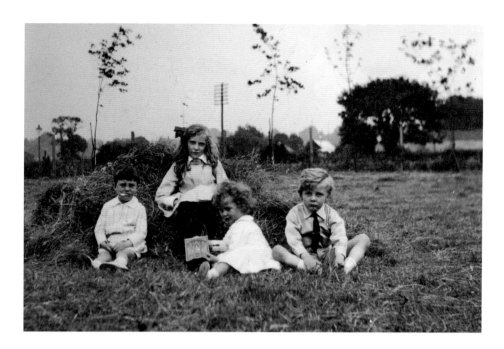

In the Hayfield, the View to Cross Elms

Some of Edward Sargent's grandchildren sit in the hay during the family's annual haymaking party at Ashburnham, Coombe Lane, in July 1915. To the right of the photograph above, beyond the tree, the long outbuilding then adjoining The Cross Elms may be glimpsed, while to the left of the tree the slates of one of the Red House Farm's outbuildings shines bright in the sunshine. The lower picture entitled 'gossiping' shows the same field, now covered by Woodland Grove, during haymaking on 24 June 1913. A horse lorry, en route from Clifton, trundles along Coombe Lane behind the women. Spare horses for achieving hills walk behind. A solitary roof in Red House Lane shines brightly mid picture.

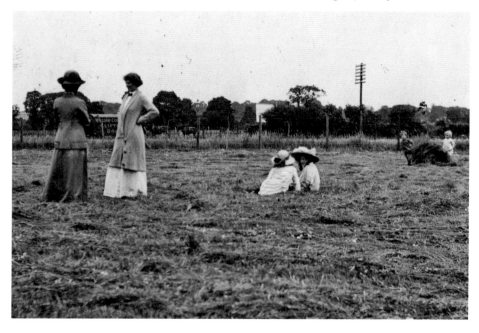

'Those Aspiring Agriculturalists of Stoke Bishop'

The wealthy Bristolian escapees of Stoke Bishop delighted in agriculturalism. The Popes of Stoke Lodge boasted prize-winning poultry, while others bred dairy cattle on their estates. Here, Ruby Sargent attends to the needs of Ashburnham's hens with the corn basket on 3 April 1917. Poultry keeping was a vital part of a household's economy. In these days of urban foxes it comes as a shock to discover that in January 1898 the inhabitants of Stoke Bishop and Sneyd Park were astonished and dismayed to find their poultry preyed on by a rapacious fox. This caused great amusement in Bristol as an oft-quoted reason for the areas not joining the city was their rusticity. It was suggested that the fox had been imported on purpose to prove a point! In another sort of country pursuit, Gladstone and Vi Sargent pause with their nets while hunting butterflies on 1 July 1917.

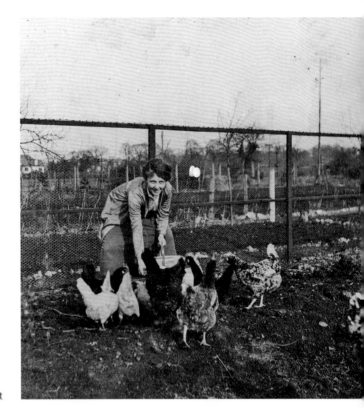

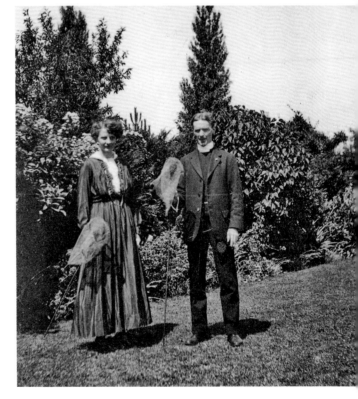

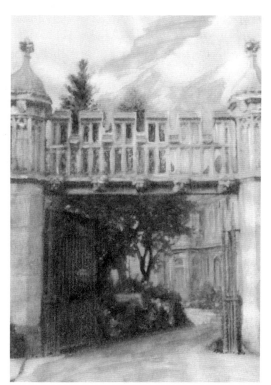

Gothic Grandeur

The gateway to William Studley's Combe Rocke as recorded in a watercolour drawing around 1920. The house had been built some years before Studley purchased the architectural stonework from the Salisbury Club that was demolished for the City Art Gallery, so the gateway was the only part of it to be used there. The recording shows the long-lost pierced gothic gallery that ran between the gateposts' ogee domes. This had originally topped the oriel window on the entrance tower to the Salisbury Club. Studley adapted this gateway from the main carriage entrance to the club, even reusing the same twisted barley-sugar iron gates that appear in photographs of the Queen's Road establishment. The gates were lost to salvage in the Second World War and the gallery had been removed by the 1950s. The gateway fortunately survived the demolition of Combe Rocke in the late 1960s and was infilled with rubble from the house.

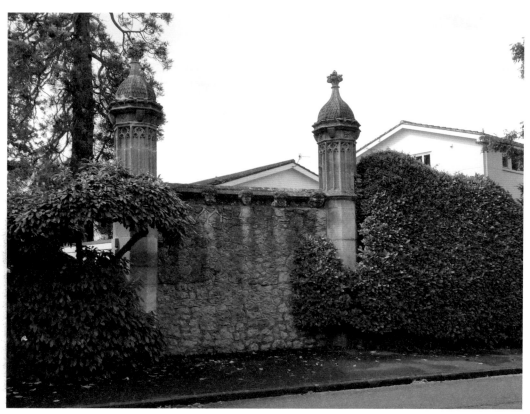

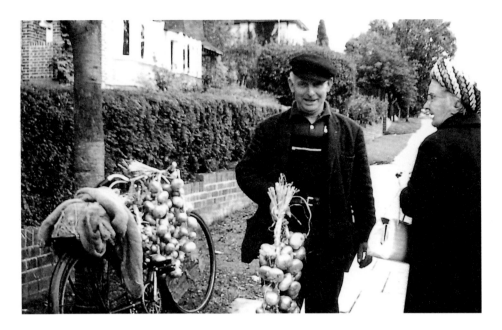

'But, Mmm, I Love Onions....'

With purse in her gloved hands, an eager housewife purchases several strings of pink Roscoff onions from Eugene in Bell Barn Road in September 1968. This Breton farmer and his bicycle were a seasonal manifestation in the north-western suburbs of Bristol until the 1980s. Breton farmers (known as Onion Johnnies) began the trade around 1828, when the journey to England via the Channel was easier than that to Paris. The crop would be brought to Britain in July and stored in rented barns until the sellers returned home in December. In 1929, 1,400 sellers covered Britain, but by 1973 import restrictions had reduced them to 160 and by 2000 to only twenty. Both ends of Bell Barn Road (photographed below in 1971) were developed separately in the 1930s and replaced a footpath to Wood End. The central section was only laid down around 1952. The road's name is said to enshrine a barn on Haytor's Farm.

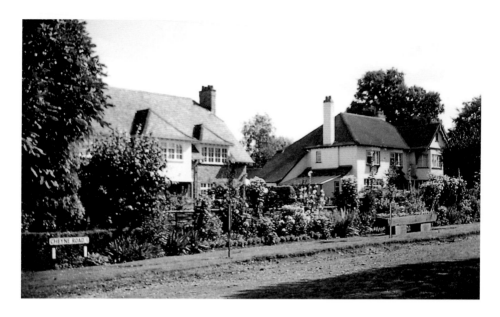

Cheyne Road, Beautiful but Unadopted

Plans for Cheyne Road's first house were submitted in 1929 and five substantial detached properties rose during the 1930s and the others in the early 1950s. Stride Brothers were responsible for most of the earlier houses, as they were for many others in the district. This development off the Shirehampton Road was known as the Stoke Paddock estate from its proximity with Stoke Lodge. Possibly because this beautiful road, named after Chelsea's Cheyne Walk, was laid down before the connecting section of Bell Barn Road existed, it remains unadopted by the council and, although improved recently, is roughly surfaced. The above view taken in 1968 shows The Halt and its neighbour. Laurels have since replaced herbaceous borders, and trees, then saplings, are now pollarded. Ebenezer Lane running at the rear of these houses gave access from Parry's Lane to Stoke Lodge's north gatehouse and to Ebenezer House, now replaced by Haytor Park.

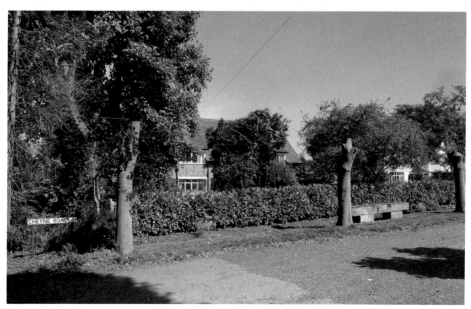

44

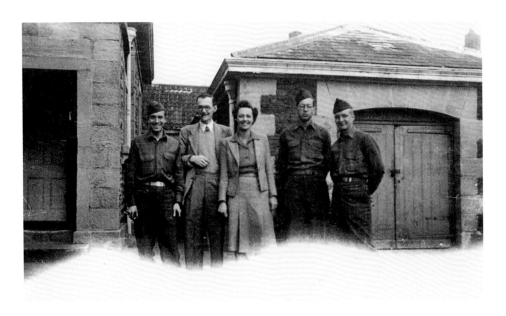

Over There ... and with the Elliott Family in 1944

Matthew A. Marvin, David Weaver, and Bruce Kramlich pose with their hosts, Mr and Mrs Herbert Elliott of Stokewood, Bell Barn Road, outside an unidentified Bristol building. Many GIs were happily billeted with local families and were generally well received. Black servicemen are often said to have been the politest. Sometimes, as with the Elliotts, lasting friendships formed. However, Not everyone approached the GI influx correctly. One woman telephoned the Bristol liaison office requesting six officers to attend her Sunday tea party. This charitable act was somewhat spoiled by her insistence that none must be Jewish. The officer taking the call was himself Jewish, and so granted her wish by sending her six black GIs. Her subsequent success as a hostess is unknown. Stokewood, like many of the houses of Bell Barn Road, was built by Strides whose yard, succeeded by a garage, stood next to the shop that became the Millhouse pub.

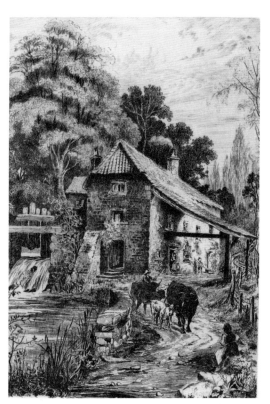

'The Ancient and Second Mill up the Trym'

Clack (sometimes Black) Mill existed in Tudor times. Although there are reports of grain milling, by the 1880s it was stamping out iron posts for fencing, which were used (and survive) locally and exported to Australia. It then became an apple store for the neighbouring orchards, until turned into a crude sawmill for a firewood business. By 1928, disused and with Sea Mills estate on its doorstep, Frederick Jones bewailed how its bridge had been altered to become 'unbeautiful' and a poultry run had turned its flowery banks to mud. After demolition in 1937, its surroundings were changed completely by soil dumping. The present canalised river course was once the mill leat, while a pond (used for swimming by local children) fronted its sluice-gate, and joined to the original river's meander on the west. This was bridged by the footpath to Coombe Dale. The photograph below reverses the view in Collet's etching and shows attached cottages.

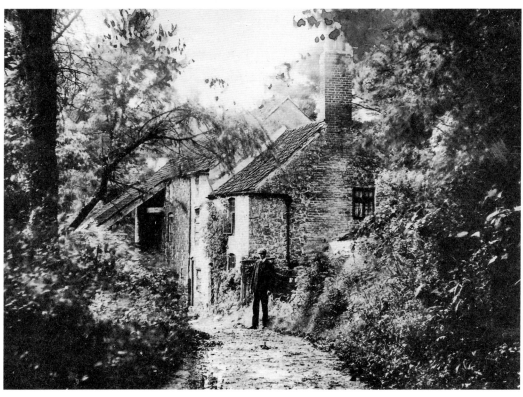

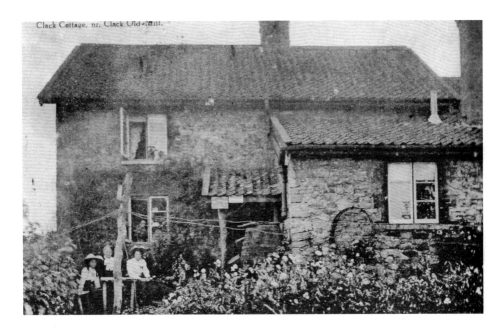

Clack Cottage, nr. Clack Old Mill.

Tea at Clack Farm, 1904

Clack Farmhouse stood below where Silklands Grove now stands. This postcard, entitled 'Clack Cottage', shows the rear of the farmhouse from the east. A rectangular farmyard once fronted the building and the path over the river ran as today, just beyond the hedge to the left to join the forerunner of Coombe Dale and to continue up the hill. The farm had a small tea garden and its shop, presumably in the same building, sold mineral waters and later sweets and toys up until the 1930s. A flood in October 1935 swept away fowl houses, drowning many birds. In 1936, the owner, Mrs Edwards, sold the farm and adjoining mill and estate of 14½ acres to the council for £3,500, who intended to preserve it as a beauty spot. Alas, both farmhouse and mill were demolished, the meandering river, additional mill-leat and pond infilled or canalised, and a sewer laid through the valley.

Walk Three

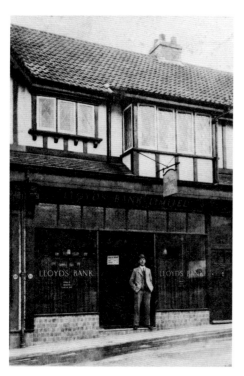

Bank Manager of the Second Village, April 1937
Ronald Parker Curtis (1906–2008) at Lloyds
Bank, Wood End, number 86 Shirehampton
Road. Monmouth-born Curtis came to Bristol
in 1925 and later saw distinguished wartime
service in the RAF, being mentioned in
despatches. A member of Shirehampton
golf club for seventy years, he was greatly
involved in the course's restoration after its
wartime use as an Army camp. Wood End's
northern Tudoresque shopping parade was
built by 1927; the second followed. They
survived as shops until the 1990s when most
became office premises. Paul Burns, social
photographer by appointment to HRH the
Prince of Wales, remains at number 72. Luton
& Sons, baker's shop at number 82 with its
beaten copper window ornamentation, long
retained its original internal shop-fittings. Sea
Mills residents often referred to the area as
'the second village'. A farm once stood where
numbers 56–58 Shirehampton Road now stand.
Its land encompassed 39 acres and included two
cottages in Sea Mills Lane.

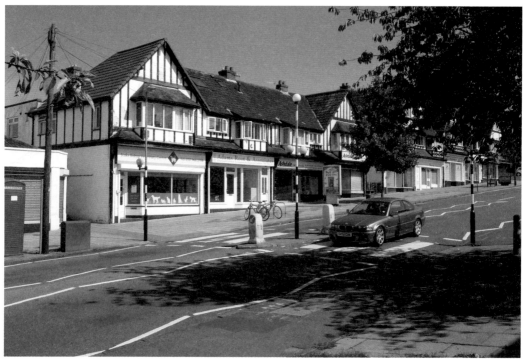

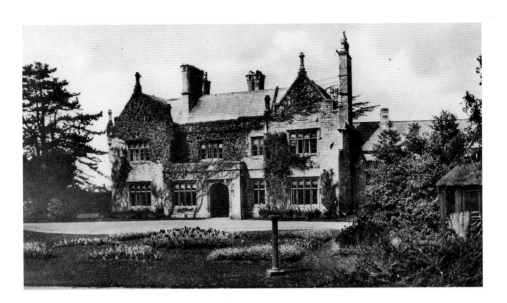

Stoke Lodge 'in the Elizabethan Style and Substantially Built'

In 1835/36, a new house arose adjoining an earlier property on the Shirehampton Turnpike Road. It boasted reception rooms, 'spacious kitchens' (above arched cellars), eight bedrooms, water closets and piped water. It appears to have been a speculation of William Munro, 'forty years a magistrate for Gloucestershire', whose seat was the nearby Georgian mansion Druid's Stoke. Munro seemingly never lived in the new house. Its purchaser and (according to later sale notices) first resident was solicitor Thomas Bowman. By May 1847, Bowman's declining health made a country residence hazardous and the house was advertised but did not sell. Bowman died in February 1848 and in May and June 1849 both the house and its contents were auctioned. The new owners were solicitors George and Andrew Pope. On George's death in 1888 William Edward Budgett, a great opponent of Bristol's expansion and the first of a succession of notable owners, purchased and enlarged the house.

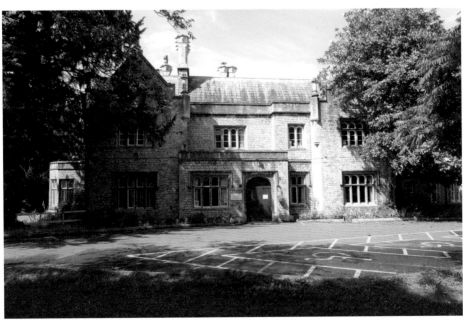

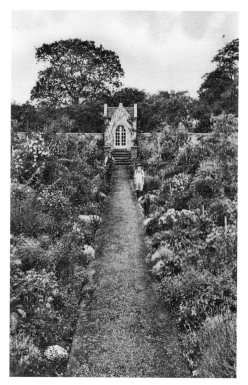

'The Gardens are in the First Order'

Gardeners pose in Stoke Lodge's superb walled flower garden around 1930, now replaced by an unlovely car park. The gazebo, possibly eighteenth century in date, gave occupiers spectacular views to Blaise, King's Weston and Portishead Point. Fruit trees clothed the walls of the kitchen garden and orchard. Outbuildings (now mostly ruinous), originally included stabling for four horses, a coach house, harness room with servants' bedroom above, and a wood-house. The Misses Butlin owned the house at the time of the photograph on the left. The Corporation bought it from Gertrude, the last of the three, in October 1947, intending a transformation into 'a multi lateral grammar, secondary technical school'. It temporarily became a nursery nurses' training college and then, in the mid-1960s, a centre for adult education. Its remaining 27 acres have provided 10 acres of school playing fields and it is a green space jealously to be guarded by Bristolians against development.

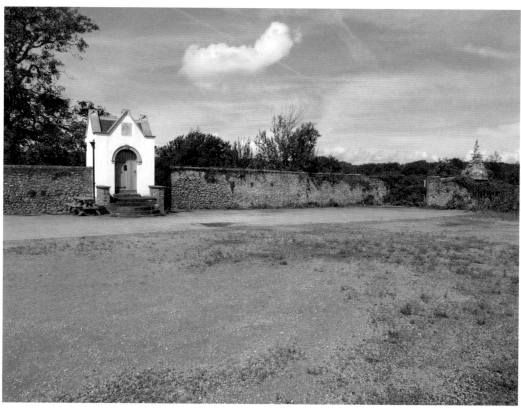

Snow at Stoke Lodge, 22 March 1917

Snow blankets the north entrance lodge and park at Stoke Lodge. The photograph above shows some of the now ruinous or demolished outbuildings that once clustered about the walled flower garden, while only a great chimney stack and roof of the main house peep from behind a cedar. The house's main entrance seems always to have been from the Shirehampton Turnpike Road but, like neighbouring Druid Stoke, it also at first lacked a lodge. By the 1880s, a drive had been laid across the park to the north and a lodge built that was approached down Ebenezer Lane (an approach to Ebenezer House) and was connected to the crossroads at the bottom of Paddy's Well Lane. The lodge house still survives as two cottages, as seen below in 2013. It is extended at both ends, and with additional gables. The entrance to the drive was where the garden gate is now.

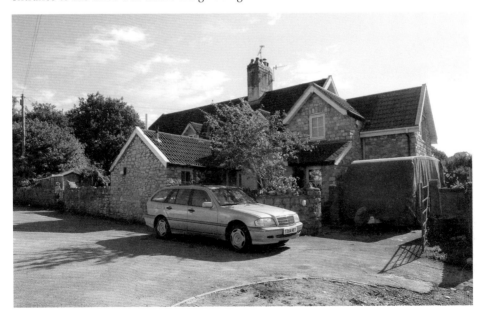

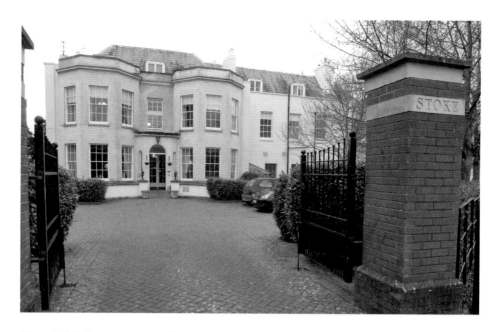

'Most Salubrious ... Commodious Sittings in Westbury Church'

Druid Stoke was an early Georgian house once owned by the Lloyd's and, by 1793, Mr Skidmore. The enlarged house was, by the 1830s at least, William Munro's residence. He died on 1 February 1856 aged seventy-five. The estate with its mansion, gardens, woodlands, '80 acres of pasture and arable' and Westbury pew, sold for £12,000 on 5 June to the wholesale grocer Thomas Wedmore JP. Wedmore let it, but later resided there, probably adding the lodge to its walnut and elm lined drive. In July 1861, the estate advertised 'walnut trees and coalpit timber' as products. On Wedmore's death the estate was auctioned in October 1899 but attracted no interest. The house's contents had sold that April but the estate sale was delayed by a family squabble culminating in a Court of Chancery decision. The drive became Druid Stoke Avenue in the 1900s when R. Milverton Drake's handsome Arts and Crafts residences arose.

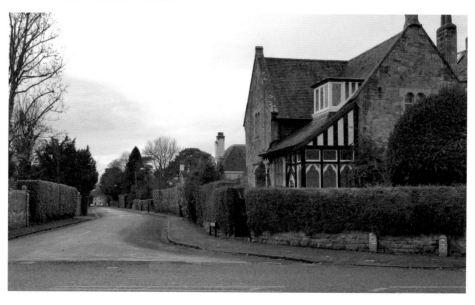

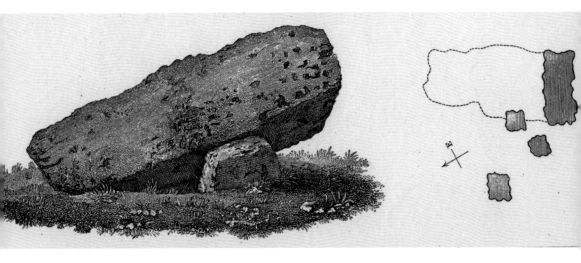

'A Remarkably Fine Cromlech'

Bristol's oldest architectural monument dates from the Neolithic period (*c.* 2800–2400 BC) and is the collapsed burial chamber of a long barrow that crowns Druid Hill (once Butcher's Hill). Seyer recorded it for his Memoirs of Bristol, 1823, when it lay in the park of Druid Stoke House to which it suggested the name. In 1899, 2 acres of parkland was advertised for sale and houses developed. The Cromlech was built in 1907 and included its ancient namesake as an admired centrepiece within its grounds. Until 1983, the monument was clearly visible from the road but, quite unbelievably, planning permission was given for a house to be built in the garden and a brick wall constructed within inches of the tomb. Since that date, unfortunately, prolific plant growth has resulted in the obfuscation of this important Bristol monument, reputed in folklore to be a missile used by the giant Goram.

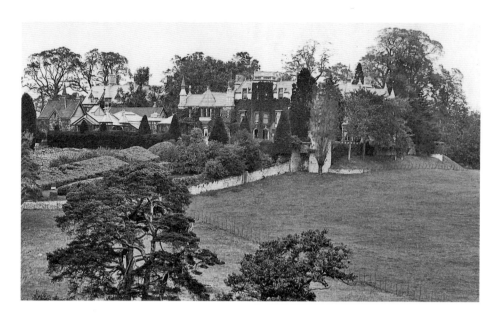

'The Moderate-Sized, Stone-Built Residence'

Resembling a small hilltop town, Old Sneed Park covers its historic hill above around 1900, during the occupancy of Francis Tagart JP, who remodelled and enlarged the ancient house. On the northern side an elaborate conservatory joined the house to substantial outbuildings. The gables of Little Sneed model farm may be seen behind. The spectacular gardens with their topiary walks were opened annually to Bristolians, and the place colloquially became known as 'Tagart's Park'. The house, with its octagonal prospect tower, sat on a terrace, with crenellated boundary walls and bastions, overlooking the deer park. Later, for many years Sir George White's residence; following his death it eventually became a Catholic orphanage and boys' school called Nazareth House. A huge extension was then built over the conservatory site. The vacated school was demolished in 1972 after a mystery fire and Glenarvon Park built on its site. The bastions and garden walls partially survive.

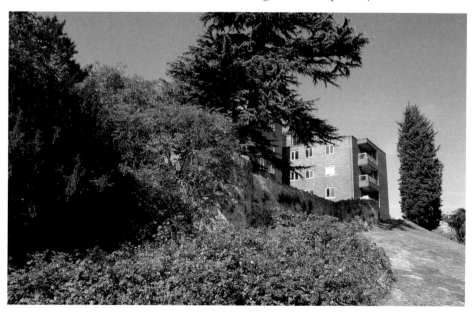

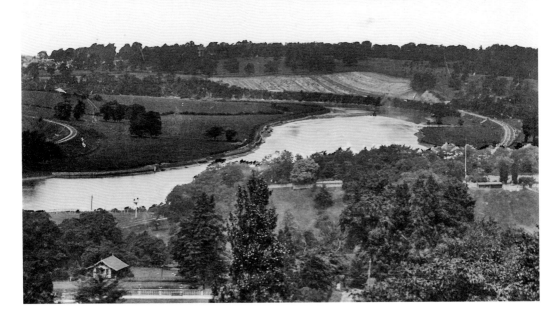

The Prospect from the Tower, 1910

A rare view taken from the prospect tower of Old Sneed Park looking north-west towards Horseshoe Bend and Shirehampton Park. Prospect towers, perhaps influenced by Stoke House or Cook's Folly, were a feature of several houses in the area. The photograph above affords a unique opportunity to view part of the formal hillside gardens of Old Sneed Park. In the left foreground a balustraded walk borders an upper terrace lawn; the urns all sport flowers. Steps lead to a meadow and a substantial Swiss chalet. At a lower level a meadow terminates in a huge terrace wall. Ramps lead to an upper walk and in the right distance, a buttressed bastion holding a possible pool rises to the roof height of an attached sports pavilion. Beyond, the cutting made in the rocks of Shirehampton Park for the Port & Pier Railway, strikingly shows its geological strata. The reverse view of the western garden below is dated 1904.

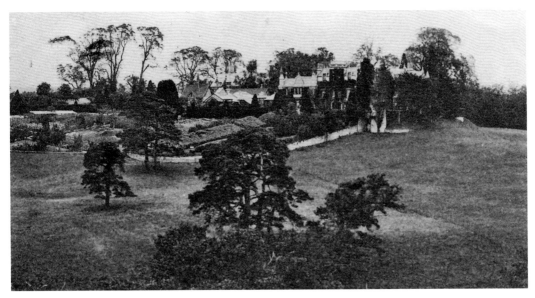

55

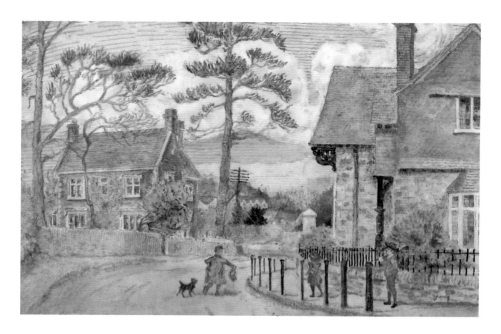

'The Within Mentioned Close of Land Called Court Hay'

In September 1891, builder William Edward Studley obtained permission to build a house and post office on his land at the bottom of Stoke Hill fronting the old Shirehampton turnpike. Called Court Hay, the 3-acre field had originally belonged to Abraham Hilhouse of The Glen. According to a conveyance in the author's collection, Anne Noble Hilhouse had originally sold it in 1867. Completed by 1892, Studley's attractive stone and brick building displays his monogram. The post office and shop occupied the room seen to the right of the front door. He sold the rest of the field to John Chetwood Chetwood-Aitken, owner of The Glen. The post office was later superseded and the building given to the village as a men's club, but it was ultimately sold. In 1926, the Shirehampton Road was rerouted through the middle of Court Hay and shops and parts of both Old Sneed Avenue and Road subsequently built on it.

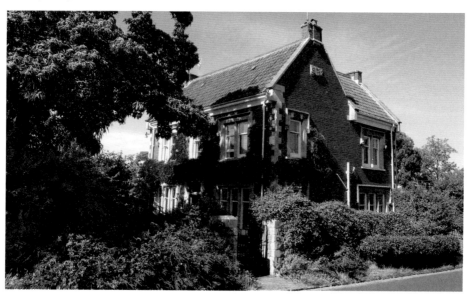

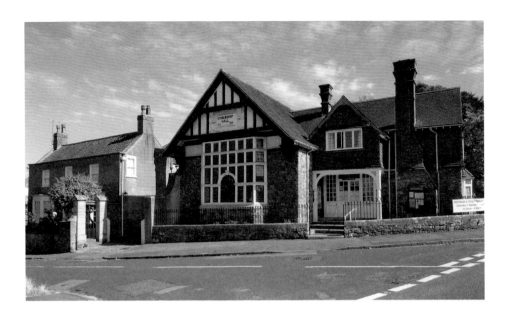

'Mr Gabriel's Hall'

In May 1884, the Stoke Bishop Reading Room Committee leased a plot of land in the village for the purpose of erecting a village hall and reading rooms. The project cost over £400 and demolished and replaced The Three Stars, the dilapidated but only inn in the area. Supported by some wealthy residents, Thomas Cox of Redland applied in August for a license to replace it by erecting an alehouse elsewhere in the village. Great opposition from other influential locals, and a division between licensing magistrates, resulted in its rejection. It was claimed that thousands of Bristolians would come to the village on Sundays when drinking was prohibited in the city, and a local police station would thus be needed! The stone and tile hung, Arts and Crafts style hall is by Edward Gabriel. Its glory is the great mullioned bay window. Thereafter, events such as winter concerts helped to pay off construction debts.

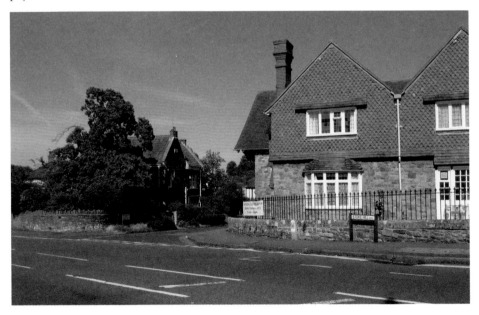

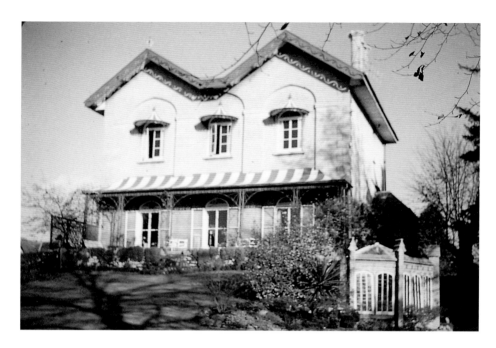

'I Detest England but … as a Thinking Nation She is Probably the Foremost'
Four elegant villas had risen beside the King's Weston turnpike road on Stoke Hill by the mid-1830s. They probably arose following the posthumous sale of Sir Henry Cann Lippincott's estate in 1832. Vashni Lodge (later Evendine), and now number 38, photographed here in 1969 and 2013, was perhaps the most remarkable with its Tudoresque features, pierced bargeboards, gable finials and tented veranda and first floor windows. Tudoresque garden buildings completed the ensemble. Between 1878 and 1888 it was the residence of the Portuguese author and consul José Maria de Eça de Queiroz. His masterpiece, *The Maias*, was written there. Although he spent fifteen years in England he was not enamoured of her: 'Everything about this society is disagreeable to me, from its limited way of thinking to its indecent way of cooking vegetables.' In 1960, the Bristol Civic Society sponsored a plaque to de Queiroz here that was unveiled by the Portuguese ambassador.

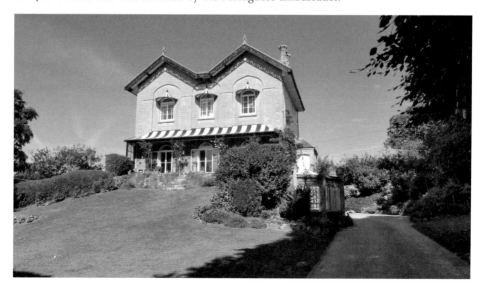

St Mary Magdalene, 'a Thanksgiving for the Mercies of a Lifetime'

On 22 May 1851, *The Bristol Mercury* reported plans to build a new church for the 500 inhabitants of Sea Mills, Stoke Bishop and the surrounding area. Westbury parish church was already crowded and new villas would further increase the congregation. Commenced in 1858, the first stage of architect John Norton's St Mary Magdalene's saw consecration in 1860 followed by additions in 1864 and the tower in 1871. The spire, having collapsed in a storm, was replaced in 1872. In November 1883, the bishop blessed the newly enlarged chancel and south chapel. The clock was given in April 1884 by Henry Oldland of Avongrove and was made by Pots & Sons of Leeds who had supplied the clock for Lincoln Cathedral. Bristol's Joseph Bell & Sons executed the stained glass. Ever willing to bring the comfort of religion to the darkest of places 'the liberal parish of Stoke Bishop' amusingly 'supported a missionary in Easton'.

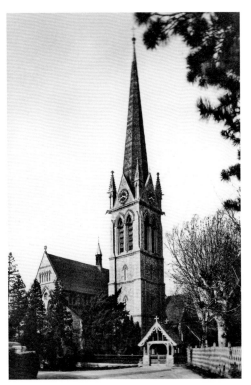

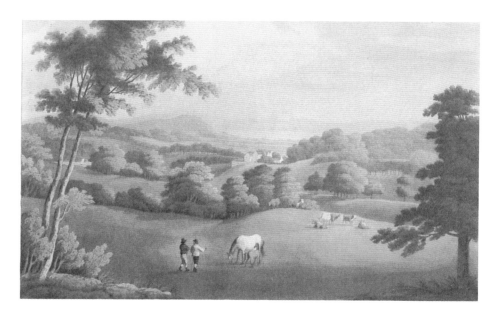

'Most Beautiful and Diversified Views of the Valleys of Stoke and Sneed Park'

'Sneyd Park', a coloured aquatint of 1810 by Clark & Duberg after the drawing by Samuel Anstie, captured the view towards the valley of the Avon and the Severn Channel from the slopes below Stoke House. What little then existed of Stoke Bishop village, 'in a compressed valley, at the foot of inconsiderable hills', is off canvas to the right. A corner of Old Sneyd Park with its terraced castellated wall appears white on the hill. The print omits the wall's bastions that certainly then existed and the house is inaccurately portrayed suggesting that the etchers misunderstood Anstie's sketch. The aquatint, however, captures in spirit the beauty and stunning vistas that made the area so popular with visitors in the eighteenth and nineteenth centuries. Now only the deer park valley below the house remains undeveloped and a nature reserve. Woodland now covers its slopes and the stone-lined nineteenth-century pond has been restored.

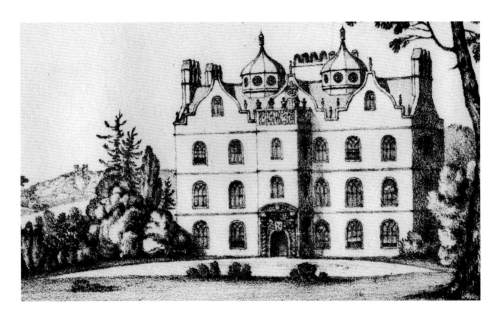

'An Antient and Singular Mansion Worth Describing'

An 1820 lithograph of Stoke House before later alterations to the then stuccoed and ochre-painted façade. The prospects to Blaise and King's Weston from the house and park were then famous. In 1791 the young Turner painted Stoke, the owner, Sir Henry Cann Lippincott, and his friends the Narraways. The early 1800s saw the house sold but not the estate, which was retained until the sale of 24 May 1832, following Sir Henry's death. Built by Sir Robert Cann in 1669 to replace an earlier building, by 1774 Stoke House passed to Henry Lippincott. A variety of owners later held it. Perhaps the most tragic was Louis P. Nott whose three sons were killed in the First World War. Later, Canynge House girls' school occupied the building followed by Clifton Theological College. In 1971, it became Trinity College. With its Flemish gables, cupolas and tower the house would influence later villas in the area.

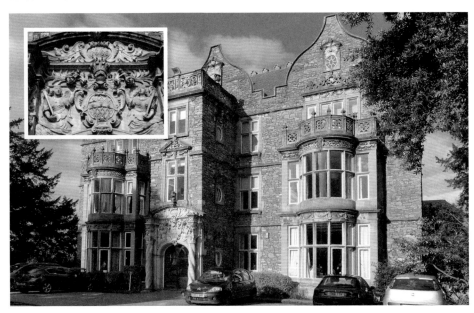

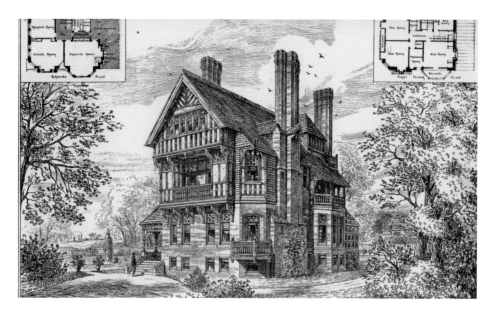

'Burglariously Breaking into and Entering', Stokeleigh, Once Ecclesbourne

Maurice Adams' drawing of Ecclesbourne, later renamed Stokeleigh, when owned, from his marriage in 1880 by John Henry Clarke, solicitor, director of B&NS Railway, secretary of the Commercial Rooms and captain of 1st Gloucester Rifle Volunteer Corps. It was one of only two houses above Church Road and its garden stretched back to Pitch and Pay Lane. A compact, Tudoresque house of 1877 by the London architect Henry Shaw. Stone built and tile hung, its half-timbered open galleries alluded to Chester's Rows. Morning and dining rooms lay to the right of the porch, and a conservatory clasped the rear façade. Originally Stokeleigh overlooked a cricket pitch in Stoke House's grounds. On 18 June 1888, it was the scene of a silver burglary by a one-eyed man from Torquay that shocked Stoke Bishop. The burglar (later apprehended) drank a bottle of champagne on the job. The house is now Stokeleigh Care Home.

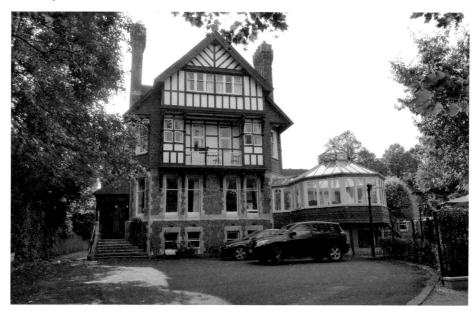

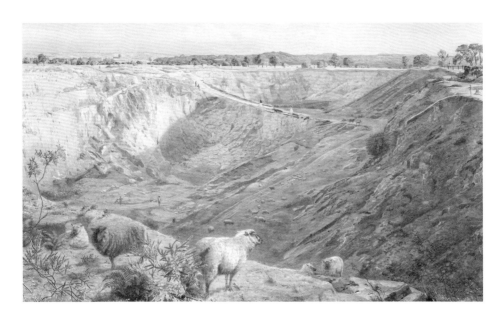

'Selling the Sublime and Beautiful by the Boatload'
William Arnée Frank's 1861 watercolour looking towards Clifton and Dundry across Durdham Down from Stoke Road, north of Ladies Mile. Durdham Downs in the late eighteenth and nineteenth centuries in no way resembled today's parkland. It was a working environment, grazed by sheep and dotted with quarries producing both building stone and lime. Quarrymen's ravages in the gorge had long been despaired of. An 1857 invoice survives from Henry Every's Stoke and Westbury White Lime Quarries of Durdham Down, showing that, surprisingly, the firm also delivered dung, hay and straw to clients. After the forming of the Downs Committee in 1861, steps were taken to fence the quarries in and finally fill the largest with alluvium from the floating harbour improvements. From 1867, a steam engine wound cars containing spoil from the river up a tramway constructed up the side of the Avon Gorge. Nowadays only the Glen remains unfilled.

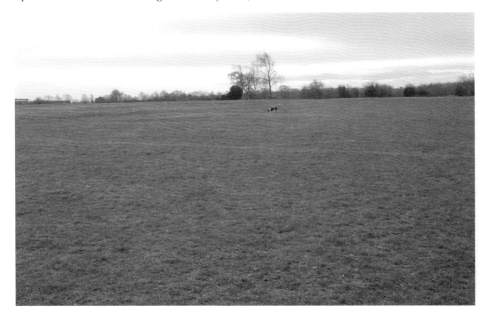

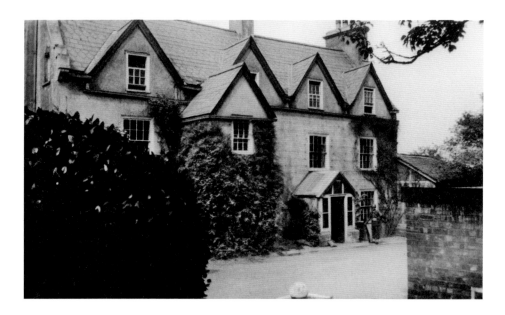

'The Farm called Pitch and Pay'

The original farmhouse bordering the Roman road reputedly dated from 1561. This was altered and added to over the centuries especially when owned in the nineteenth century by the soap manufacturer Charles Thomas, of Christopher Thomas & Brothers, of Broad Plain. A new garden front and conservatory in the Flemish Renaissance style rose behind the original building and contrasted with its vernacular facade (seen below in 1944). Newspapers record the Thomas family supporting good causes. On 20 February 1883, Mrs Charles Thomas held a fully attended 'drawing room meeting' on women's suffrage to hear an address by Miss Tod of Belfast, while the following month Herbert Thomas presided over an anti-slavery meeting. In 1938, the 54-acre estate was auctioned but the house was soon requisitioned for the war effort. Although the lower lodge still survives in Church Road, the house was demolished in 1962 and replaced by Span's Pitch and Pay Park.

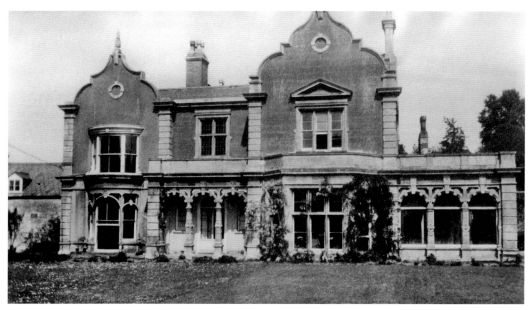

The Yanks at Pitch and Pay House

Bruce Kramlich's photograph of GIs James Whitby (left) and Dave Weaver (right), both members of the 304th Port Company, 519th Port Battalion, in front of the conservatory at Pitch and Pay sometime between April and May 1944. Like many of the large houses of north Bristol it had been requisitioned to house military personnel. The single American is Larry Botson of the 519th HQ Company. Following a return to domesticity after the war, the house finally gave way to Span's new 4-acre estate of houses and flats. Designed by Michael Hitchings of Towning Hill & Partners and developed between 1961 to 1965 for Span (London) Ltd, the development won praise at the time for its retention of existing trees, landscaping and architectural design. It appears less admirable nowadays in parts after infilling altered the original plans published in 1962's *Architectural Review*, and increased both properties and tar-macadam.

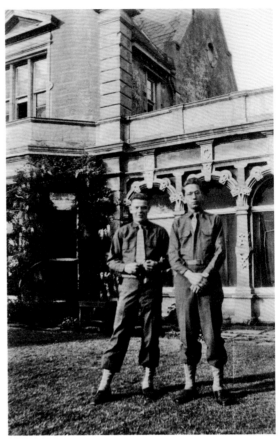

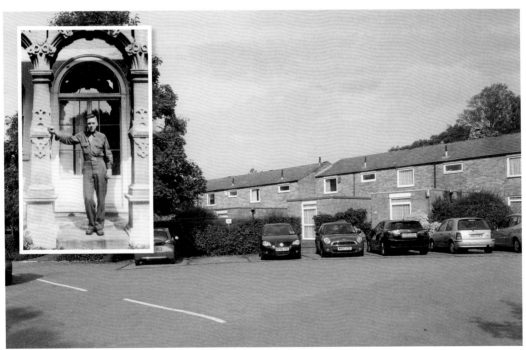

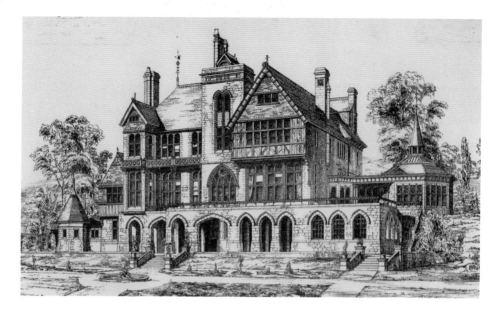

'Well Known in Commercial Circles', Woodlands, 1876

Bordered by Mariner's Path, the Roman Via Julia, Woodlands' gardens sloped from Church Road to Church Avenue. Designed by Stuart Colman for the respected wine merchant Augustus Phillips (1815–96), it is a grand, visually complicated, house composed of grouped architectural blocks reminiscent of a crammed townscape from a manuscript illumination. Its eclectic style perches between medieval and Elizabethan and the garden and entrance facades differed considerably. To the right of the entrance façade (below) was the low, gabled, butler's bedroom and pantry, while to the left was a 'book room'. The garden façade featured half-timbering and tile-hung gables. A veranda fronted the dining room while the drawing room opened to a terrace supported by gothic arches. An 'aquarium' (presumably a fishpond) was inserted into this, below which was the billiard room. Close by, an octagonal conservatory, now replaced by a post-1940s block, aped a medieval kitchen complete with a louvre.

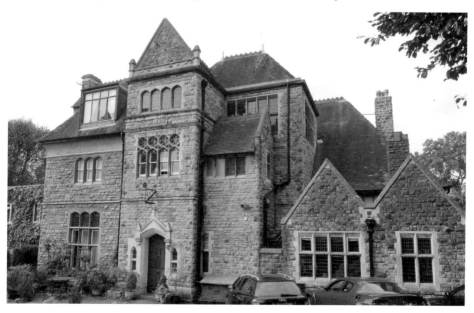

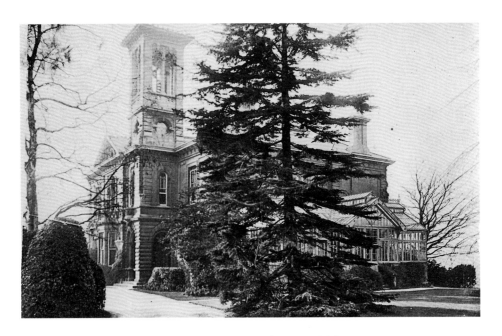

'This is the House I Live In, But It Don't Show the Best Side'

Thus did Alice refer to Oakfield when writing to her friend Lottie Miles at Tortworth Court near Falfield in 1910. This huge, and now lost, residence lay in extensive grounds on the terraced northern slopes of Sneyd Park. Built around 1855, its lodge and main entrance lay on the west side of Julian Road. Its architectural style might be termed Italianate, with its pediment and campanile. The northern façade, ('the best side') had bay windows overlooking the steeply terraced gardens and enjoyed the wonderful view to the Severn Estuary. The house became the South West Forensic Science Laboratory after the Second World War but was, alas, demolished during the 1980s when so many of the great houses gave way to new flats and infilling. The site is now occupied by the Marklands development and Julian Close. Its lodge survives as a private house.

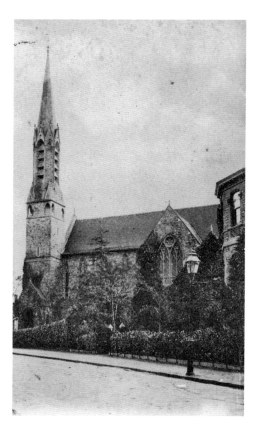

'An Ornament to the Neighbourhood', Christ Church

Stuart Colman's Christ Church opened in Julian Road on 12 September 1878. The building cost £6,600 and was larger than was actually needed in order to accommodate projected future congregations. Previously Congregationalists had faced a muddy drive or tramp across the road-less Downs to worship. Given the quality of the area's houses, it was felt that 'God's house should not be inferior in quality or style to the surrounding dwellings'. Timber vaulted and built in local yellow sandstone with Bath stone tracery and mouldings it was decoratively restrained, although adorned with an elaborately illuminated hammered iron screen in Passion flower design by Harris & Sons of Marsh Street Iron Works. Although praised locally, *Building News* criticised 'Unlimited pretensions with limited means and consequent failure', considering the towering spire unnecessary and mere competition for that of St Mary's. Falling attendances and lack of funds saw Christ Church close in 1962 and replaced by Julian Court.

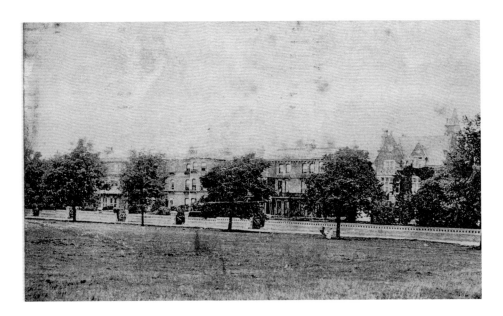

'Blots on the Landscape', Rockleaze, 1878

'Is it possible to say anything in praise of the row of huge box-like semi-detached villas in grey limestone and blue slate with the usual "dressing" forming part of what is known as "Rockleaze", which faces one when crossing Durdham Down? They serve as an index for much which lies beyond – houses set down on the most charming sites, commanding views rarely, if ever, to be surpassed, but themselves blots on the landscape without one redeeming feature except such as the ivy and creeping plants, which do not belong to them, furnish.' Thus the *Building News* of 20 September 1878 castigated the Sneyd Park developments. Of particular annoyance was their rejection of warm, multicoloured building stones and tile, available locally, in favour of those colder examples employed. A June 1865 advertisement discloses that the houses boasted nine bedrooms and 13-foot-high reception rooms. E. W. Godwin designed a smaller, polychromatic pair, now numbers 10–11.

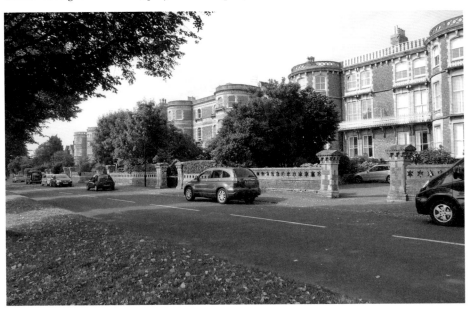

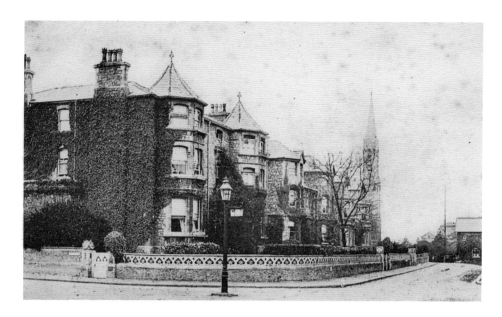

Nuisances on the Downs

The unfortunates of Stoke Bishop and Sneyd Park, marooned in their comfortable villas beyond the city boundaries and free from contributing to its rates, still complained of their lot. No direct metalled route across the Downs existed for the convenience of residents near Rockleaze and even traditional everyday Downs pursuits occasioned annoyance. Professional carpet beating was allowed on an acre of the nearly 500 acres of the Downs allotted for pleasure. Newspaper correspondence in June 1885 grumbled of gentlefolk incommoded by dust while viewing may blossom, and by the constant thudding of the beating. A Stoke Bishop 'Sufferer' complained of having to pass them four or five times a day. Impervious to the protests of those engaged in 'an honest livelihood', the Downs Committee immediately banned the practise. Concurrently, complaints were voiced over the Sabbath's desecration by bands playing on the Downs on Sunday evenings for public amusement. The photographs show Rockleaze Villas and Downleaze in 1904.

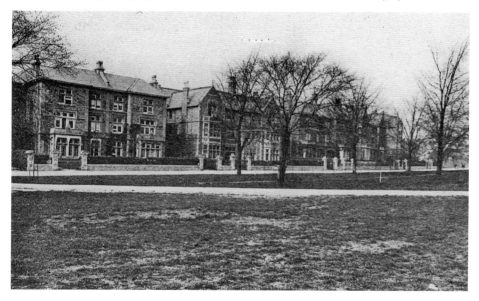

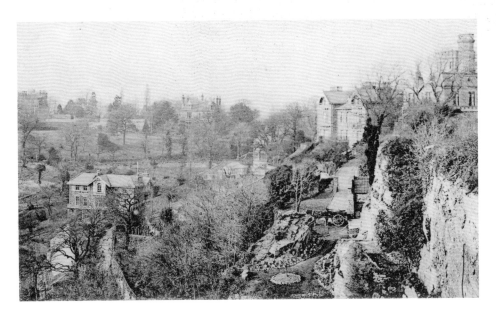

'The Constantly Increasing Mansions of Sneyd Park and Stoke Bishop'

Some of the mansions on the slopes beyond Sea Walls around 1900. On the right stands Tower Hirst with its attached prospect tower, while beyond it are semi-detached Locarno and Sea Walls. A horse and cart wait in Locarno's rustic garden while neighbouring Sea Walls features a formal terraced garden complete with a magnificent octagonal gazebo. Occupying a triangular space at a lower level stands the quintagonal Avonwood with its line of glasshouses. Mid-picture, high on the hillside above it, stands Avon Grove in its huge park that swept down the hillside to border the Port and Pier Railway. On the extreme left the distant bulk of Cook's Folly closes the scene. In 1933, Avon Grove, was converted to two houses and new houses developed in the grounds. Locarno and Sea Walls were demolished in 1972 and Tower Hirst requisitioned in 1946 at first as refreshment rooms for Downs visitors and then for flats.

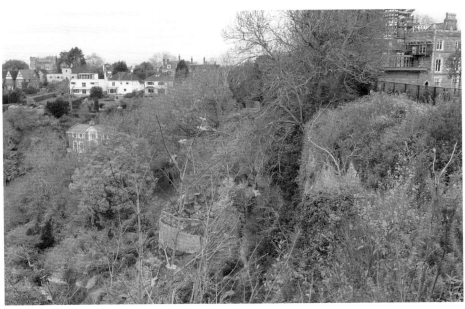

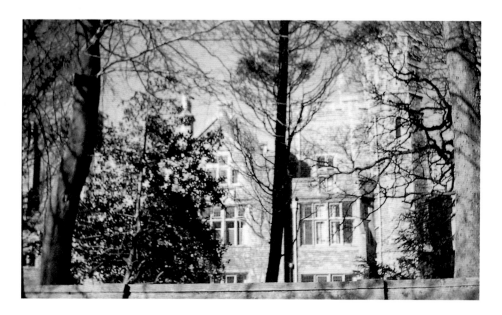

The Towers, Née Ivy Towers, 1967

In 1894, following a world tour, Edward Robinson Esq. of the wholesale stationery company E. S. & A. Robinson commissioned his wife's cousin, the architect Alfred Gotch, FSA FRIBA of the Kettering firm of Gotch & Saunders to enlarge and remodel Ivy Towers previously owned by G. A. Tilney. It adjoined his late father's property Sneyd Park House. By December 1895, when it hosted a family wedding for 200 guests, it was renamed 'The Towers'. Gothic and castellated in inspiration, with a porte cochère on the southern entrance façade that appears above, it housed the Robinson family until 1947 when it was acquired as a permanent residential home for children by Dr Barnardo's and renamed Elizabeth Bishop House. In the late 1960s it was demolished for flats. Its extensive grounds were originally bounded by Church, Hazelwood and Goodeve Roads, while Sneyd Park House lay on its western side.

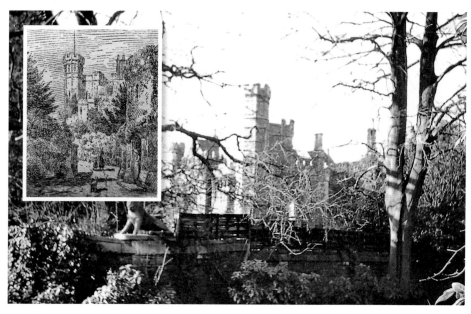

The Beasts of The Towers

Boasting an unusually substantial lodge house, one of twenty-two surviving in Sneyd Park, Ivy Towers' grounds were also surrounded by a castellated wall. This once featured two animal sculptures, perhaps in imitation of Burges' famous animal wall at Cardiff Castle. Neither appear to have been originally made for the task and presumably once stood elsewhere in the grounds or were imported. One was a heraldic bear that had originally steadied a shield with its raised paw. The other was a copy of the Uffizi boar, named thus after the Roman copy of this ancient masterwork now in Florence. It was widely reproduced in antiquity and again from the days of the Grand Tour onwards. In June 1986 the author published a paper identifying a fine copy of this masterpiece (previously catalogued as a sculpture of a lion) among the Roman sculptures that once ornamented the great thermae at Bath.

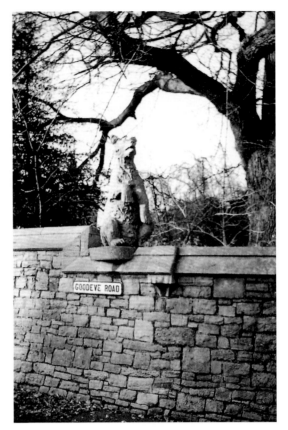

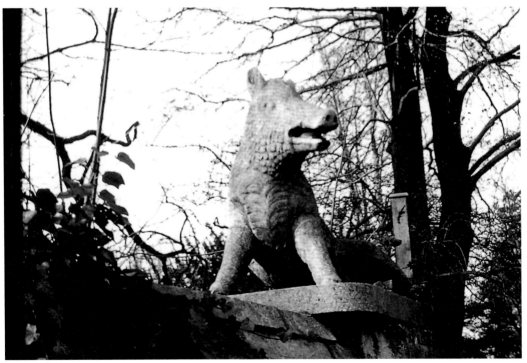

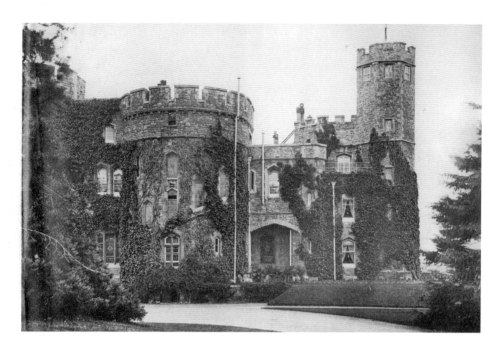

'Should I Make a Fortune, This is Where I Should Like to End my Days'

Cook's Folly tower appears on the right around 1905, attached to Dr Henry Hurry Goodeve's 1857/58 mansion. Built in 1693 (engraved 1806), by the 1850s it had become part of a popular pleasure garden, and an elevated trysting place for lovers who could obtain the key for 3d. Goodeve (1807–84) fell in love with the tower when a youth and, after a highly profitable career with the East India Company and positions in China and the Crimea, purchased the site and designed the house himself, 'preserving the integrity of the tower'. It housed exquisite Indian furniture and ceramics looted from the Imperial Palace at Peking during the Anglo-Chinese wars. Other local dignitaries such as Henry Tripp Melsom, Sir Charles Wathen and Sir Hebert Ashman followed in ownership. Wathen died before he could substantially alter the house and rename it 'The Castle'. Alas, the 1930s saw the historic tower demolished and the house divided into two residences.

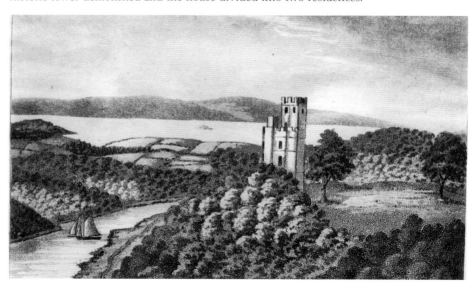

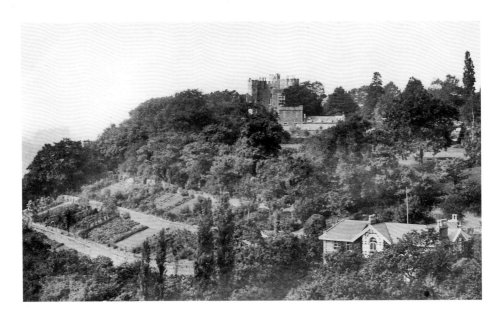

'Shady Bowers, Alcoves and Romantic Retreats', Cook's Folly

The walks, terraced vegetable gardens and woods of Cook's Folly around 1906. 10 acres of gardens descended to the gardener's cottage by the riverside. By 1884, the kitchen garden boasted a vinery and a 103 feet long 'Orchard House' housing nectarines and peach trees. Wathen redesigned the grounds in 1892 before his death. The tower's surrounding woods and winding walks had long been a landmark. As a pleasure ground, by the 1850s they attracted thousands of visitors and bands played twice weekly during the season. Although still advertised in 1856, the grounds 'doomed to be invaded by buildings' officially closed with a grand fête in September 1855. Specialities included America's Mr Ward 'on the Trapez (*sic*) amidst a blaze of fireworks' atop the folly. The pleasure ground was managed from thatched Folly Cottage. This became a tavern and burned in June 1857. Restored, it finally closed in 1860 following the death of its landlord.

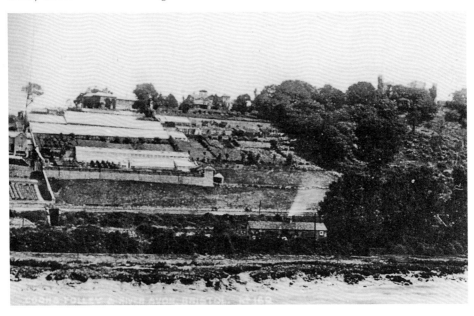

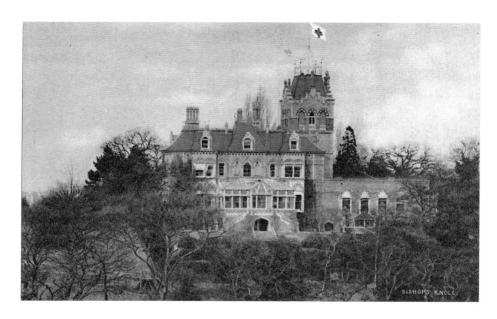

Old Colonials at The Knoll, 1915

The Knoll (later Bishop's Knoll) stood at the end of Church Road. Its builder and first owner sold it at auction on 14 April 1870. Advertisements describe its fourteen bedrooms, 42-foot-long billiard room, central heating and tower room with the rooftop belvedere. The purchaser, Peter D. Prankerd, although from Langport, had lived in South Australia. He was succeeded by Bristolian Robert Bush who himself had farmed sheep in Australia and had joined Western Australia's legislature. Bush had played cricket for Gloucestershire alongside W. G. Grace between 1874 and 1877. During the First World War he converted the house into a hundred-bed hospital for Australian troops as pictured above. Bush died there in 1939 and during the next war it became an apprentice school for BAC. From 1948 it became the Bristol Hospital School of Nursing, until its sale, demolition and replacement by unremarkable flats around 1970. The Woodland Trust now protects much of its extensive gardens.

Walk Four

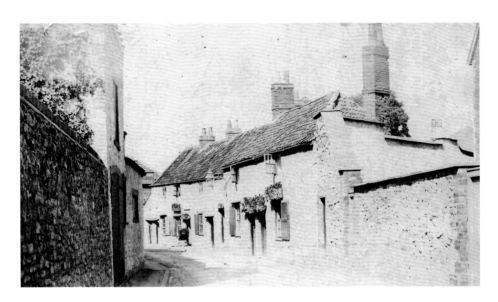

'The Little Boy Who Lives Down the Lane'
Coldharbour Lane in 1897 when it consisted of half a dozen cottages, an inn and the farm that it led to and that gave it its name. A perambulator sits outside of the open door of one of the cottages, most of which take advantage of the summer sun and air and have open windows and portals. Wooden shutters are attached to all of their ground-floor windows. Several façades are ornamented with geranium-filled flower boxes over porches and windows. Those nearest the camera follow the late Victorian rustic fashion of being clad in bark strips. Beyond them may be seen the roof and side wall of the original Cambridge Arms. A partially visible painted signboard advertises its name and that of the landlord, Thomas Burridge. On the left the garden wall and stable of Stanley Villa (lost to road widening) closes the scene. The lane became Coldharbour Road in 1904.

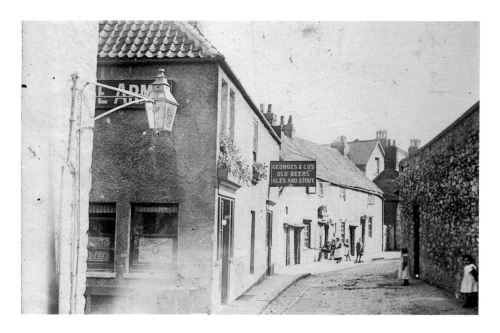

Old Beers at the Cambridge

Another photograph of Coldharbour Lane, taken the same day in 1897. This time cottagers pose for posterity and the perambulator is tenanted. The walls of Stanley Villa's stable block appear on the right. Behind the cottages appears one of the new houses of Manor Park, that had replaced the gardens of the demolished Redland Villa. Like its neighbours, the original Cambridge Arms sports geranium-packed flower boxes on its façade and has striped blinds to enliven its windows. This was then the only public house in the area and had been in existence since at least 1865. Between 1889 and 1909 Thomas Burridge was the landlord. It stood further west than the replacement building that in 1900 George's Brewery commissioned from Edward Gabriel. This is a delightful Arts and Crafts confection of brick, with Venetian windows and moulded stucco. Gabriel was also the architect in 1885 of Stoke Bishop's parish hall.

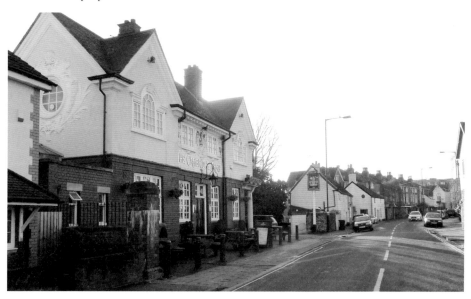

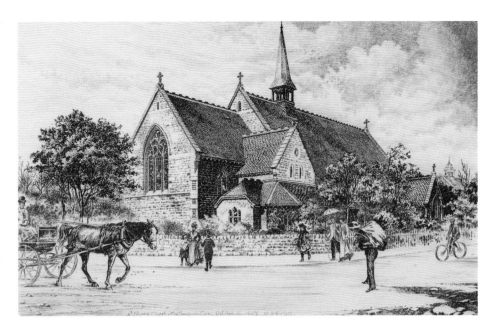

'Far Too Small', St Alban the Martyr, Westbury Park

William Vizor Collett's delightful etching of his parish church on Coldharbour Road, dated 10 October 1907. Designed by Crisp & Oatley, St Alban's was a mission church of Westbury parish church and rose between 1892 and 1894. By 1907 it had become overcrowded and a competition, won by C. F. W. Dening, decided on the shape of its successor that would rise beside it. The foundation stone was laid a month after Collett etched its predecessor. Although lacking its north-east tower the new church was completed by 1915. Old St Alban's was retained as the parish hall and is now the home of the Alban Players. Collett, of Valken, Downs Park West, Henleaze, was born in 1870 and was by profession a clerk working for Fry's chocolate factory. He was greatly respected as an etcher and painter. He died in June 1916, aged forty-five, and his funeral took place in St Alban's.

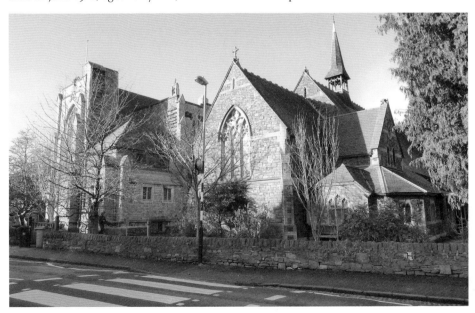

The View from the Bedroom and the Attic

Fields await the inevitable new housing development in this 1903 photograph above of the view believed to be that to the south-east across to Redland and taken from a bedroom of what was then number 23 (later renumbered to number 90) Coldharbour Road. A row of houses appears dimly in the mist. Development of Coldharbour Lane started around 1901 and by the time that the photograph was taken it was well underway and had been aggrandised into a road. Maps of this era show that it was intended to call this newly developing area New Clifton. The lower photograph was taken from the attic on 30 May 1903, looking north-east, across houses being erected in Harcourt Road. Wooden scaffolding poles appear in the foreground and fields back the development. The photographer, Edward P. M. Davey, later lived at Cross Elms (The Elms), Coombe Lane.

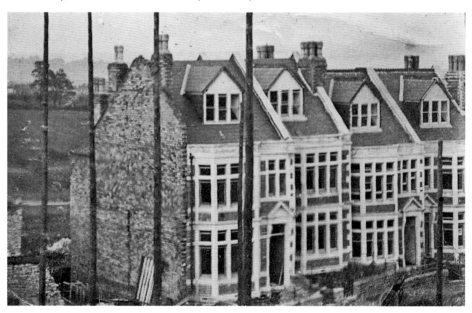

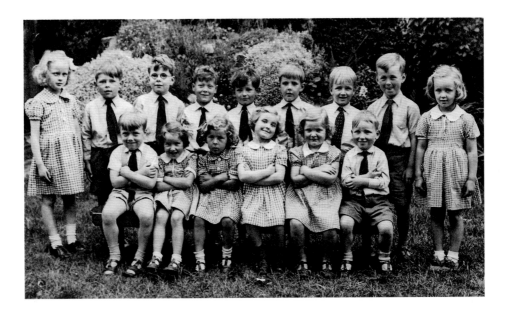

Torwood's Class of 1947

Looking well turned out, happy, and ready for all eventualities, the children of Henleaze's Torwood House school brightly face the photographer. Torwood House was a private school and advertised itself in 1947 as 'a school for girls and junior boys'. Based at number 9 Howard Road (seen below), it was run by joint Principals Mrs D. M. Baker BA Hons. and Mrs D. E. Green NFU. Torwood's pupils were gleaned from throughout the city and the school catered for parents requiring a more genteel start to their children's education. Young Alan Anstee of number 130 Avonmouth Road appears fourth from left in the back row. Founded around 1915, the school continued at the same address until the 1960s after which it moved to its present address at numbers 27–29 Durdham Park.

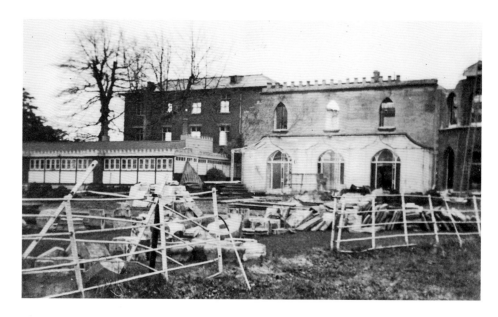

The Fall of the House of Northumberland, 1937

Northumberland House school during demolition as viewed from the east. The pretty castellated Georgian Gothick villa that was possibly the earliest part of the mansion appears stripped of its canopied veranda. The bay window to its right adjoins the main and heavier 'Baronial' northern façade with its turreted front porch. Originally called Springfield House, the name was changed to Northumberland during its occupation by Col. Heyworth-Savage. Northumberland House School was started by Miss Percy in the building in the teens of the last century and continued after her death until 1935. The house and huge estate was then sold for redevelopment, a process interrupted by the Second World War. Northumbria Drive was driven across the park providing a more convenient approach to Henleaze Road from the city. The lower view shows the west and opposite side of the school with the Gothick house to the left.

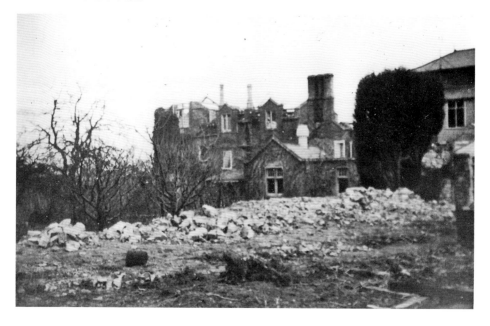

By Popular Demand

The new Northumbria Drive was soon ornamented by the moderne bulk of the architect Alec F. French's Orpheus cinema. Its façade was clad in artificial stone and neon strips led the eye from the ground through the canopy and up to spotlights in the cornice. Two flag standards were later added near the cornice. Inside, the marble-clad stalls foyer was topped and overlooked by the balcony foyer, that was constructed around a square central well. The auditorium was decorated in shades of light and dark gold, relieved with red and green. The proscenium arch was 38 feet wide by 27 high. Opened on 16 February 1938, it eventually failed in 1971 and was sold to the John Lewis Partnership. Although demolished in 1972, a successful campaign by local people resulted in a smaller three-screen cinema being included in the rebuilding. This much-loved independent Bristol institution is now part of the Scott Cinema chain.

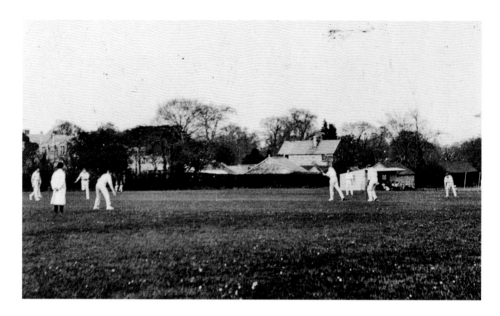

'Howzat?'

A Westbury cricket match photographed by Edward Sargent on 2 May 1908. Play takes place on the cricket and football ground that had been established in the field west of the kitchen garden enclosure of Henleaze's Springfield. The gables and western façade of the house may be seen in the left distance beyond the trees. The house's many glasshouses, stables and ancillary buildings show above the boundary hedge. To the right a new if somewhat primitive wooden pavilion provides covered seating for spectators. The cricket pitch now underlies Waitrose and the Orpheus cinema. After 1900, the houses of Downs Park West and East rose on Springfield's land to the west of the pitch. The 1936 view below from number 1 North View shows the pavilion and Springfield's stables topped with an ogee-domed bell cote. The original pitch was by this time allotments and aerial photographs appear to show a smaller sports field in front of the pavilion.

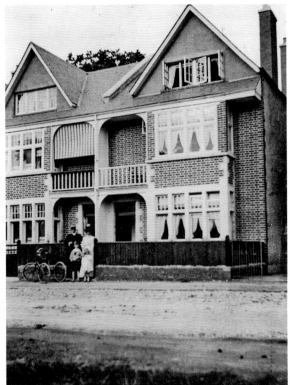

The Building of Mayfield

The smart and newly completed Arts and Crafts houses, numbers 4 to 8 Downs Park East, as seen in 1907 and photographed by Edward Sargent. To the left the silhouette of a workman tops the half raised walls of Mayfield, number 10, soon to be the home of Sargent's daughter Maude and her husband, Revd Edgar George Storey (Church of England). Mayfield and four other houses, numbers 10 to 16, were built by Dennis Cottrell in 1907/08. Cottrell also built numbers 2–32. The houses were equipped with that popular necessity of a passage and bicycle shed. The 1908 photograph below shows the Storeys at the gate of their new home with their children Kingsley and Joyce. Sargent's tricycle appears in both photographs. Jauntily striped sunblinds then shaded the houses' balconies. The earliest houses in Downs Park East rose from 1904 and were designed by Henry Dare Brian for the builders E. A. Chase and W. J. Voke.

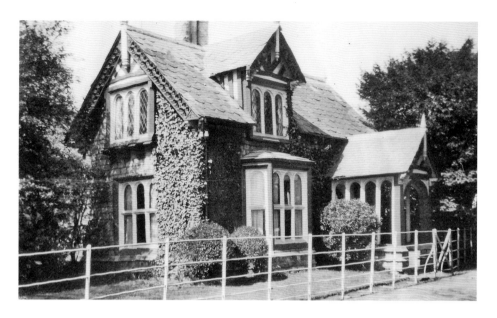

The Gardener at the Gate, 1937

Springfield Lodge, number 18 Henleaze Road, is all that remains of the house that bore its name. Reputedly dating from 1727, which would make it the earliest building in Henleaze, its exterior betrays nothing but a cottage ornée of the early nineteenth century. The pretty Tudoresque building with its screen porch and decorative, pendant gables may have inspired the details found more massively employed by W. E. Studley on his detached villas in Coombe Dingle. Beyond the pierced bargeboards the roof bears decoratively shaped slates. The 1937 photograph below was taken from where number 1 Northumbria Drive now stands and during the redevelopment of the Northumberland House estate. Houses in Henleaze Road appear beyond. In October of that year the lodge became a private dwelling and in the 1970s was home to the American singer Diane Solomon. Like many lodges it was originally the home of the house's head gardener and his family.

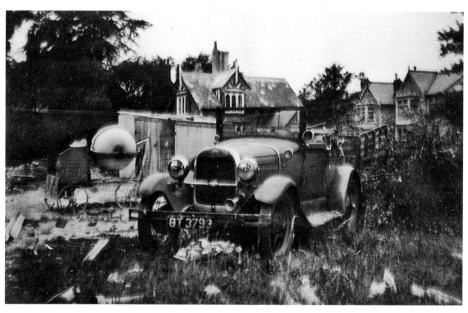

The Drive Before Northumbria Drive

The railed carriage drive to Northumberland House (Springfield) from its lodge on Henleaze Road, photographed above in the 1930s before the school was closed. The photograph, taken from a viewpoint that now equates with number 16 Northumbria Drive, shows the final stages before the drive curved to enter the wooded garden enclosure surrounding the main house and its attached buildings. Northumberland House itself stood around the present site of what is now number 43 Breandown Avenue. The iron railings are of a type widely used locally and are probably the product of the stamping mill established for some years at Clack Mill in the Dingle.

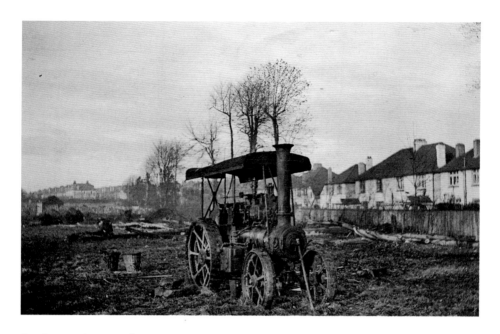

Resting on the Boundary

A Clayton & Shuttleworth steam tractor stands at the rear of numbers 40–32 Holmes Grove during the demolition of Northumbria House. Henleaze Road runs behind the estate boundary wall on the left with the houses in Henleaze Avenue and Henleaze Gardens beyond. Fallodon Way would rise on this site after the war and the picture is taken approximately where number 18 now stands. The war interrupted development on the Northumberland House estate and allotments took the place of the projected houses. After the war the land was compulsorily purchased and prefabs occupied the site from 1946 until the late 1970s. Beyond the estate boundary wall at the right was once the Henley Grove estate. Maps show that Holmes Grove was already planned as early as 1900 and that the ground had been sold for development.

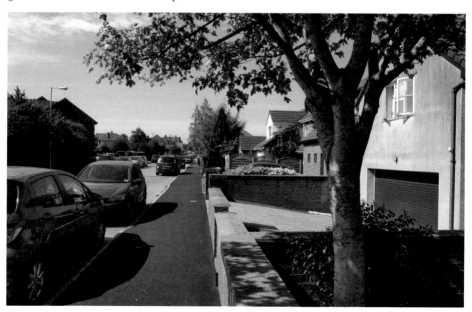

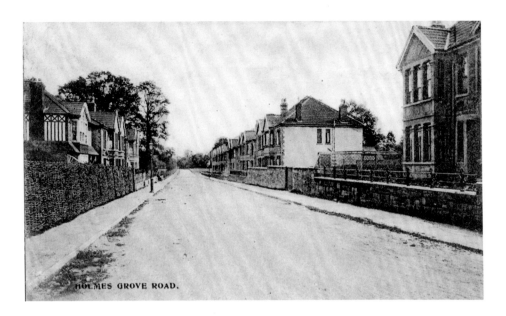

HOLMES GROVE ROAD.

'So Glad You are Coming to See Us'

Mrs Mary Gibson sent this card of the recently built houses of Holmes Grove Road to her relative in Montenotte, Ireland, on 27 June 1905. She had not long moved into number 10, Walmer House, which as she pointed out 'is the end one on the left hand side, next to the big trees'. Holmes Grove, as it is now renamed, was the first street to encroach on the Henley Grove estate and partially usurped the mansion's original entrance drive. Its construction isolated Henley Grove's lodge resulting in it becoming a private house. After its initial Edwardian building spree Holmes Grove underwent a second spate of development in 1929/30 occasioned by the prolific builder and developer Arthur Charles Edwards of number 53 Arley Hill, Redland Road, who had already constructed properties in Owen, Henley and Lawrence Groves. Edwards' developments occur throughout north-west Bristol, especially in Stoke Bishop.

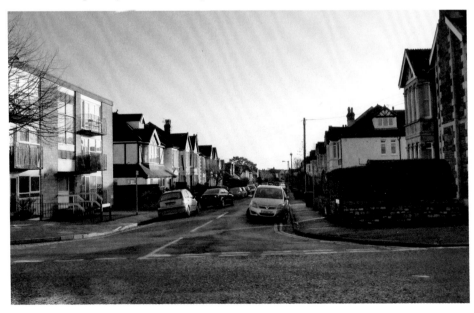

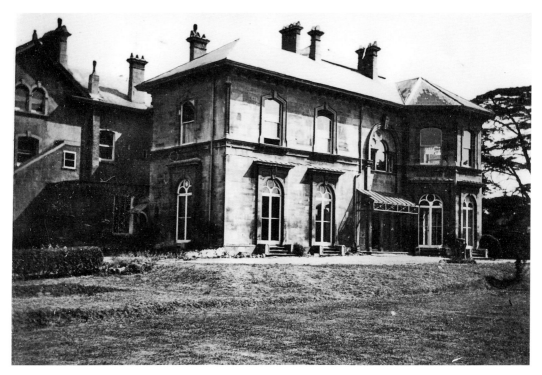

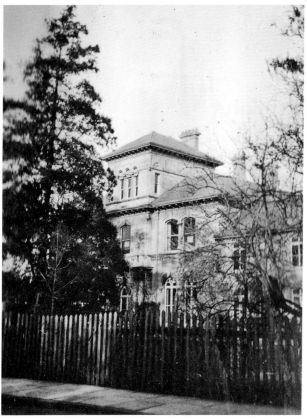

Commodious Flat for Rent, 1937
Henley Grove Mansion in 1937.
The top view is taken from the
north-west in Lawrence Grove
while the lower is from the south
in Henley Grove. Both roads had
replaced its 20-acre park and now
hemmed in the house. Reputedly
early eighteenth century in origin,
the mansion had been enlarged
and rebuilt probably after
the 1840s. Its southern façade
featured a tower. Following the
estate's sale in 1898 it was for a
while a ladies' domestic science
college before being divided
into flats. By the 1930s the park
with its specimen trees, flower
and vegetable gardens had long
given way to new housing. In
1967, the house was demolished
and replaced by townhouses. Its
original lodge survives at number
84 Henleaze Road but a second
(now number 132) that does not
appear on the 1880s Ordnance
Survey Map had been built for
the north drive by the 1890s.

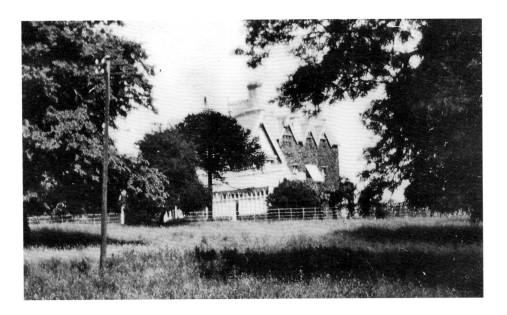

The Gables of Claremont, 1937

In May 1946, Bristol newspapers reported one of the earliest of the post-war compulsory purchases. The Corporation was to 'take over' the large Henleaze estate known as Claremont that was then the residence of Mrs Bruce Cole, for a training college for male teachers. She was 'compelled to find a new home'. Her husband had been managing director of H. J. Packer & Co. chocolate manufacturers, later Elizabeth Shaw's. Claremont lay east of Henley Grove estate. Beyond 'lovely gardens', its 7 acres of parkland, then grazed by a small dairy herd, were intended as playing fields for projected schools. The photograph above shows the house from the southwest. Built in the 1850s and formerly known as Havelock House, it became Claremont in 1873 on a change of resident. The gabled, ivy-clad eastern façade behind the Victorian conservatory dated from 1909 and was attached to a battlemented tower. Claremont became a 'special needs' school.

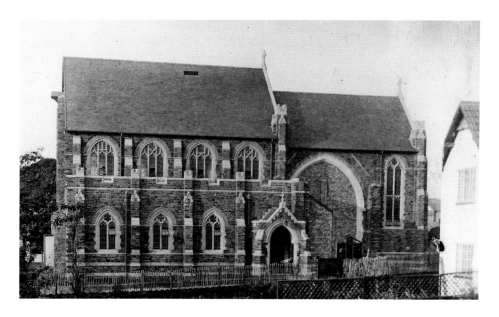

'A Legacy from the Greatest Organ Builder'

St Peter's parish church was designed in 1926 by Arthur R. Gough, the son of Bristol architect William Venn Gough. Arthur designed the 1913 wing of Bristol Grammar School and was responsible for designing or adding to several Bristol churches in the 1920s and 1930s. St Peter's took over ten years to complete. The upper photograph taken from the south shows it in 1927 while the lower depicts it from the north, nearing completion a decade later, following the addition of a Lady Chapel, three western bays, a flèche and the west front. Its organ was built by the master organ maker Henry Willis in 1869 on the commission of Henry St Vincent Ames of Cote House for Westbury's village hall. Willis' organs also graced St Paul's Cathedral and the Albert Hall. In 1927 it was sold for £200 and transferred to the new church.

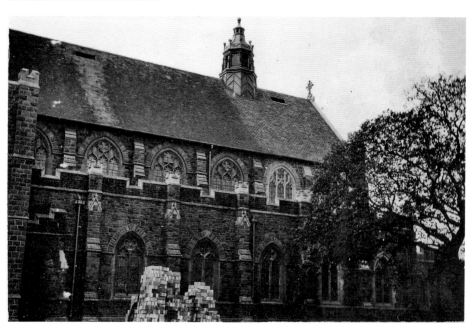

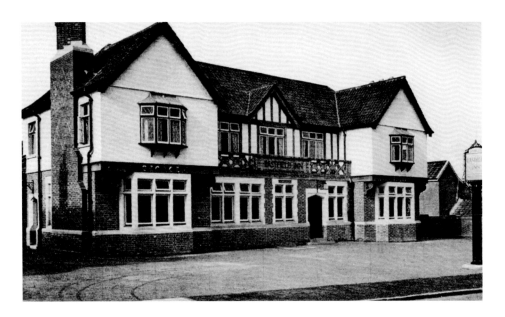

'The Modern Inn is a Home from Home'

The Eastfield Inn is absent from the 1840s tithe map but the original building was an early nineteenth-century, rather plain, double-fronted house with Georgian-style glazing and a bay window to the right of the front door that matched that of a small attached shop beyond. The first inn flanked the pavement of Henleaze Road and was famous for its flagstone floors and beers from the wood. It was certainly in business by 1861. As one of George's Brewery inns, it was rebuilt in 1934/35 in an imposing Tudoresque style behind a forecourt designed for fifty cars. The company aimed to make their houses places where 'a man could take his wife without fear of debasing conditions'. It boasted a fine garden (until recently with a pet goat), loggia and skittle alley where, in the 1940s, the Air Raid Precaution (ARP) were based. The modern skittles team is called the Eastfield Inntoxicators.

'One Lives so Intensely in Grange Park You Know'

A 1935 view of the recently built houses on the eastern side of the railed lane, subsequently aggrandised to Grange Park, that dissected common land previously used as a pony field and that had originally linked Eastfield with Henleaze Road. The substantial houses were built from 1927 onwards, mostly by the builders William and Ivor Voke and A. Rogers. The lower photograph shows the view to the north-west enjoyed from this road in 1938. Beyond the pony field may be seen the south front of the Priory. To the right behind the fencing, and bordering Eastfield, is the Priory's kitchen garden with its substantial glasshouse. At the left appears the boundary wall and buildings of Burfield House, the Red Maids' School. In 1939, Grange Close North began to be developed across this field but the War and, in 1945, 'temporary bungalows' (prefabs), usurped it. Sheltered accommodation and other housing have now replaced them.

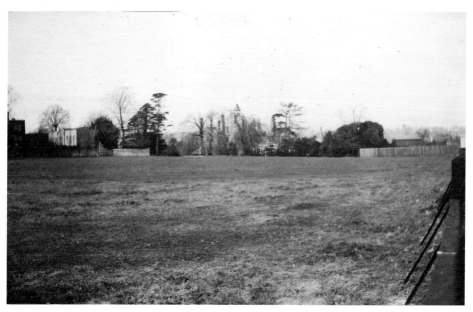

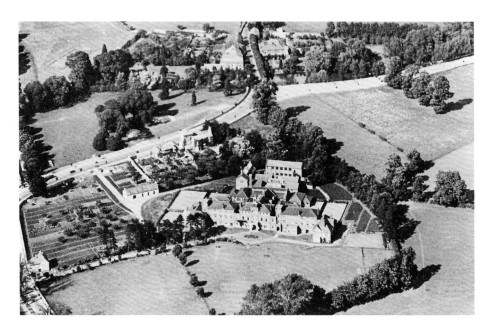

'The Building Shall be One to Which the Citizens of Bristol can Point with Pride'

Following the sale of their Queen's Road building, The Bristol Royal School for the Blind, built new premises, designed by Edward Gabriel, on the 11-acre Southmead House estate opposite the quarry on Henleaze Road. Southmead House itself faced Southmead Road and the gardens of Southmead Manor. It later became a dormitory for senior boys and classrooms where practical skills were taught. Its extensive grounds and greenhouses gave the school self-sufficiency in vegetables as the 1925 photograph above displays. From its opening in 1911 the school played a notable part in the local social scene, but by 1968 pupil numbers had dropped to such an extent that it was no longer economically viable. The estate was auctioned in 1970 and the school and Southmead House demolished in 1971. They were replaced by the Neo-Georgian Pyecroft estate. In 2011, former pupils sponsored a blue plaque on the site.

Waiting for a Water Sprite, Henleaze Lake, 30 April 1930

Warmed by tweed, young Leonard Storey awaits his intrepid sister Joyce's emergence from the ladies' changing marquee to take a springtime plunge into Henleaze Lake (her head appears in the bottom picture). The wooden diving tower rises beyond. In the previous century the lake was part of the huge quarry feeding limekilns there and elsewhere. When quarrying ceased in 1912, springwater soon filled it and it became known as Southmead Lake, being leased by Major Badock of Holmwood for fishing and boating. In 1919, the Henleaze Swimming Club was formed and was supported and allowed to use 'Henleaze Lake' by Badock who bought the quarry in 1924. The club purchased it in 1933 and flourished, hosting both local and international aquatic championships. From the start the club included an angling section, and stocked the lake with coarse fish. Henleaze Swimming Club remains today an extremely popular institution with a waiting list for membership.

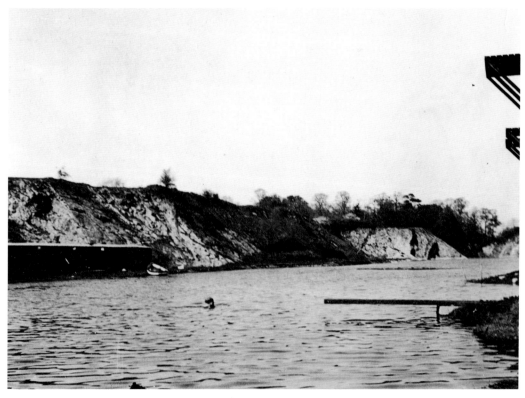